Naturaleza Oculta

Natura Invisibile

Nature Cachée

Natura Nascosta

Hidden Nature

D0186330

Original title: Hidden Nature

ISBN: 978-84-15967-72-9 – English version
ISBN: 978-84-16504-00-8 – Spanish version
ISBN: 978-84-15967-99-6 – French version
ISBN: 978-84-16504-01-5 – Italian version
ISBN: 978-84-16504-02-2 – German version

© 2015 Promopress Editions

© all illustrations TOC DE GROC

English translation: Tom Corkett
French translation: Marie-Pierre Teuler
Italian translation: Chiara Chieregato
German translation: Susanne Schartz-Laux

Copy editor & editorial coordination: Montse Borràs at Promopress Editions
Layout: Antonio G. Tomé
Cover design: proxi.me

PROMOPRESS is a commercial brand of:
Promotora de Prensa internacional S.A.
C/Ausias Marc, 124 | 08013 Barcelona (Spain)
Phone: (+34) 93 245 14 64 | Fax: (+34) 93 265 48 93
info@promopress.es
www.promopresseditions.com
Facebook: Promopress Editions | Twitter: PromopressEditions@PromopressEd

Printed in China

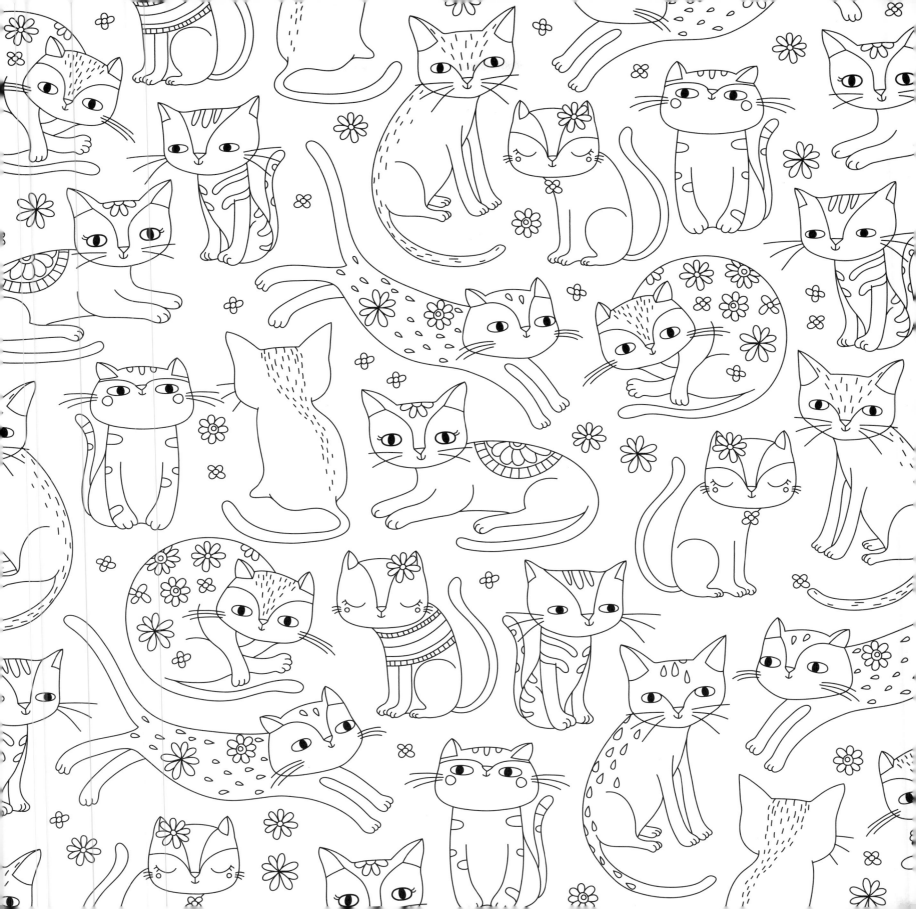

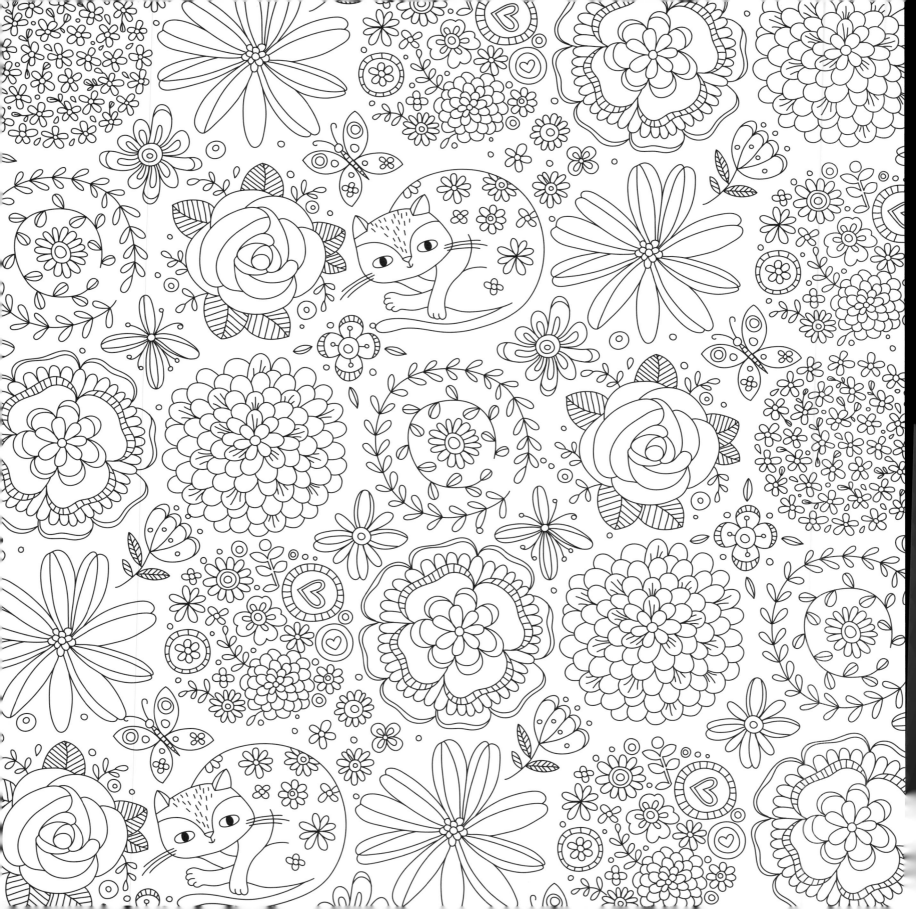

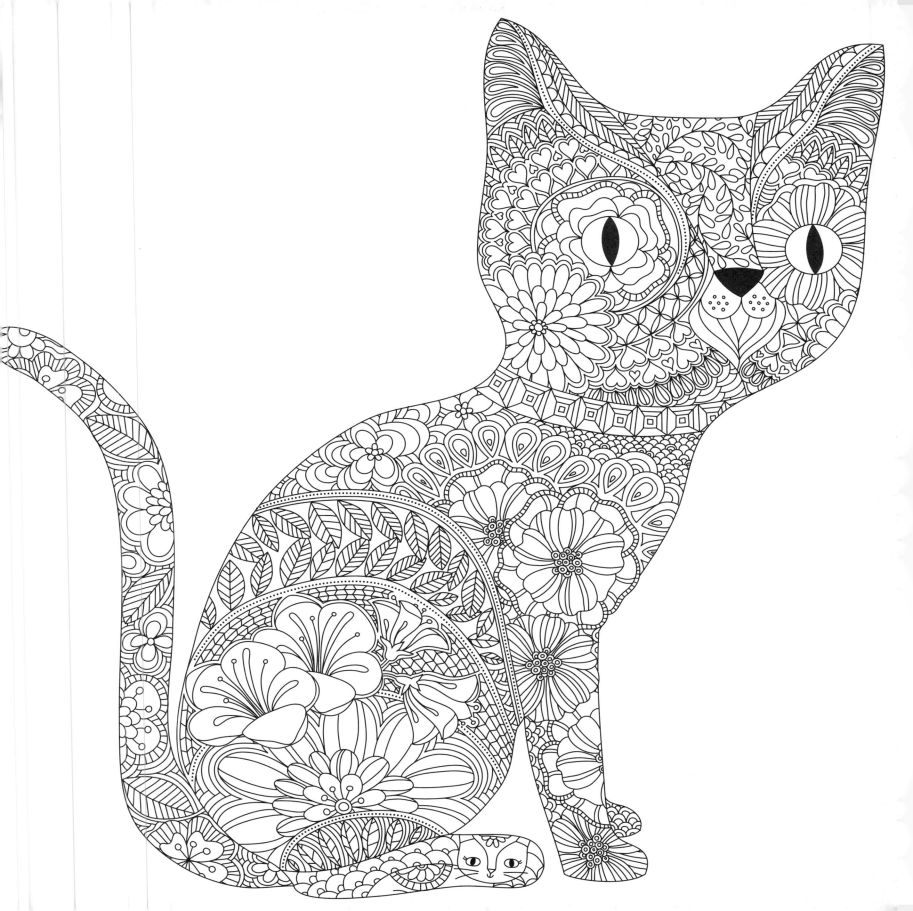

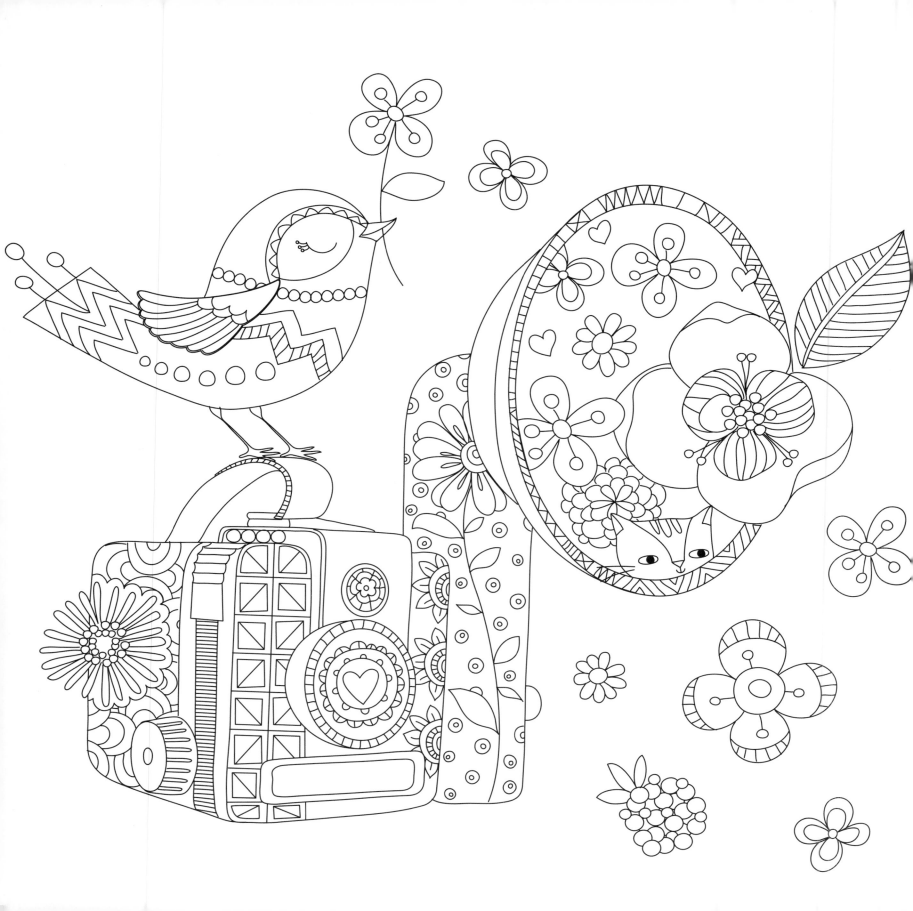

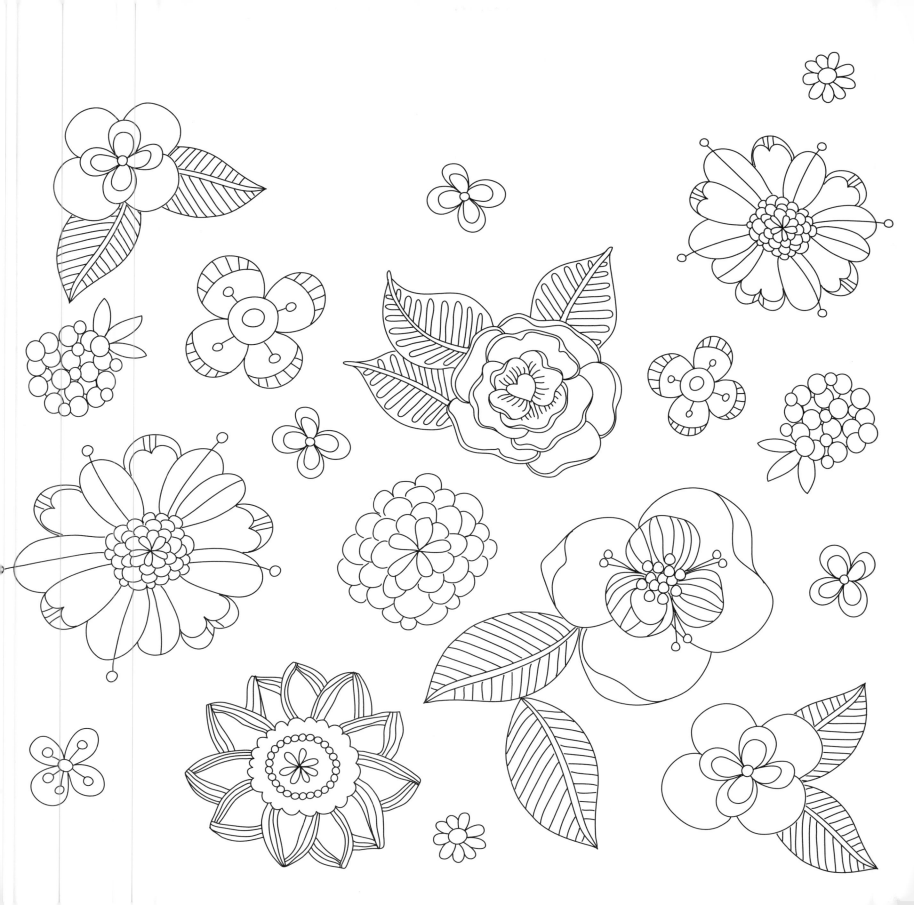

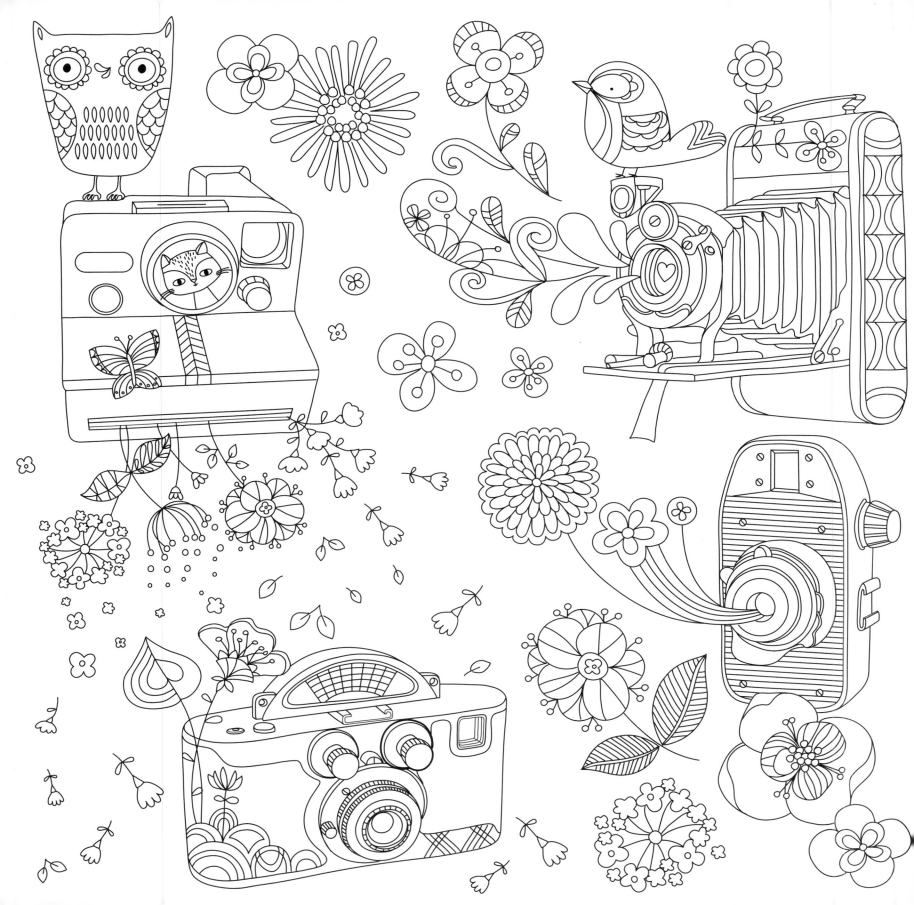

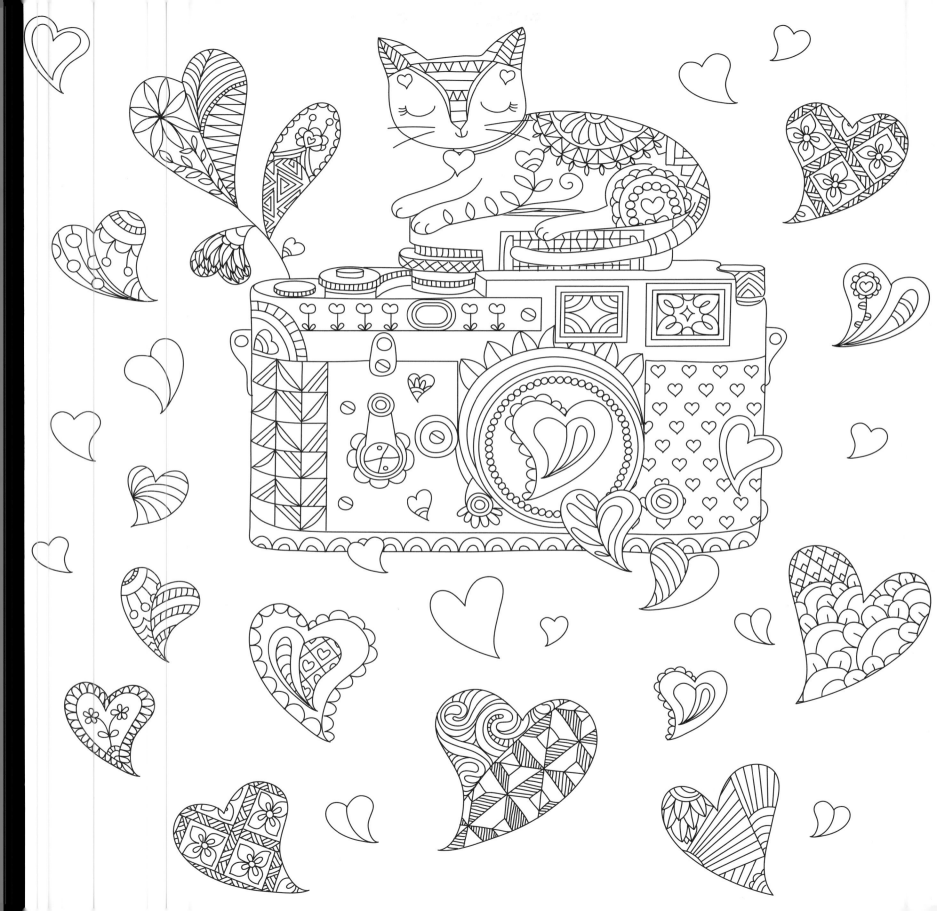

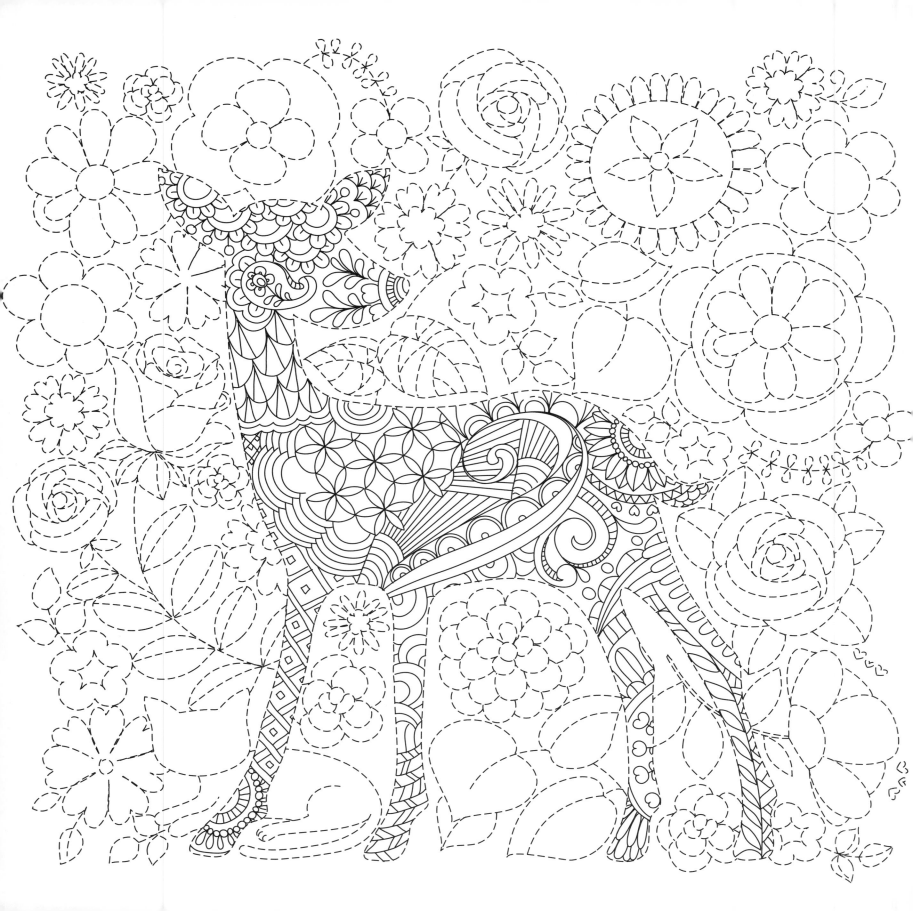

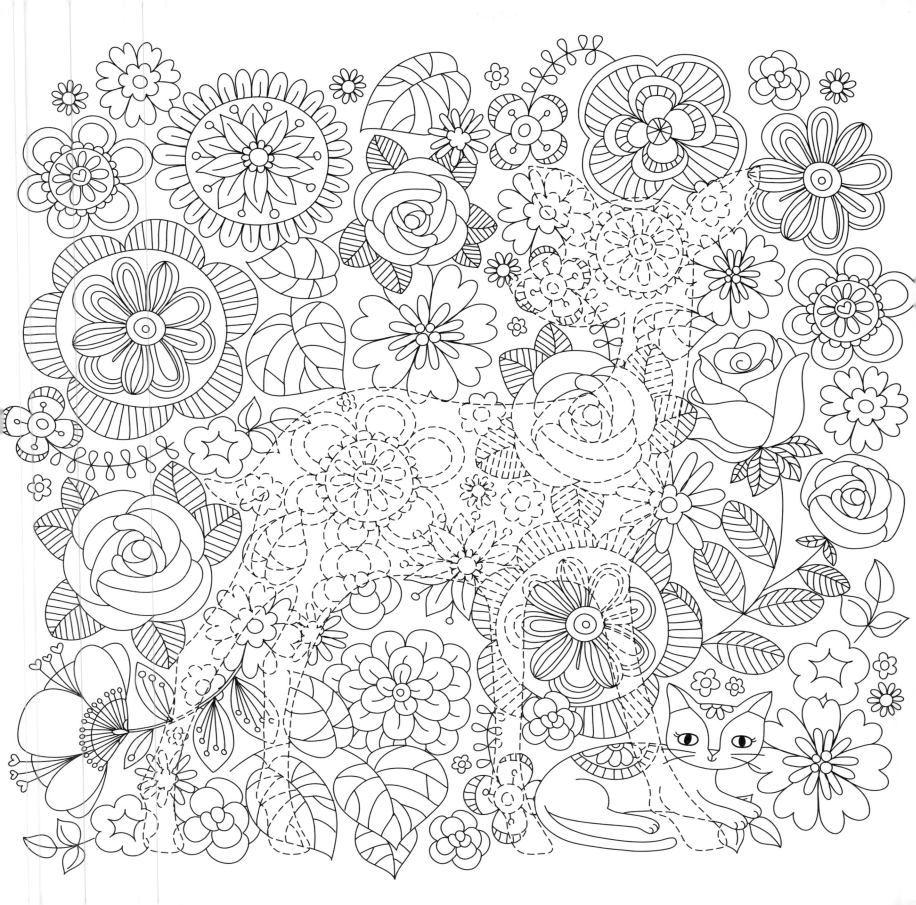

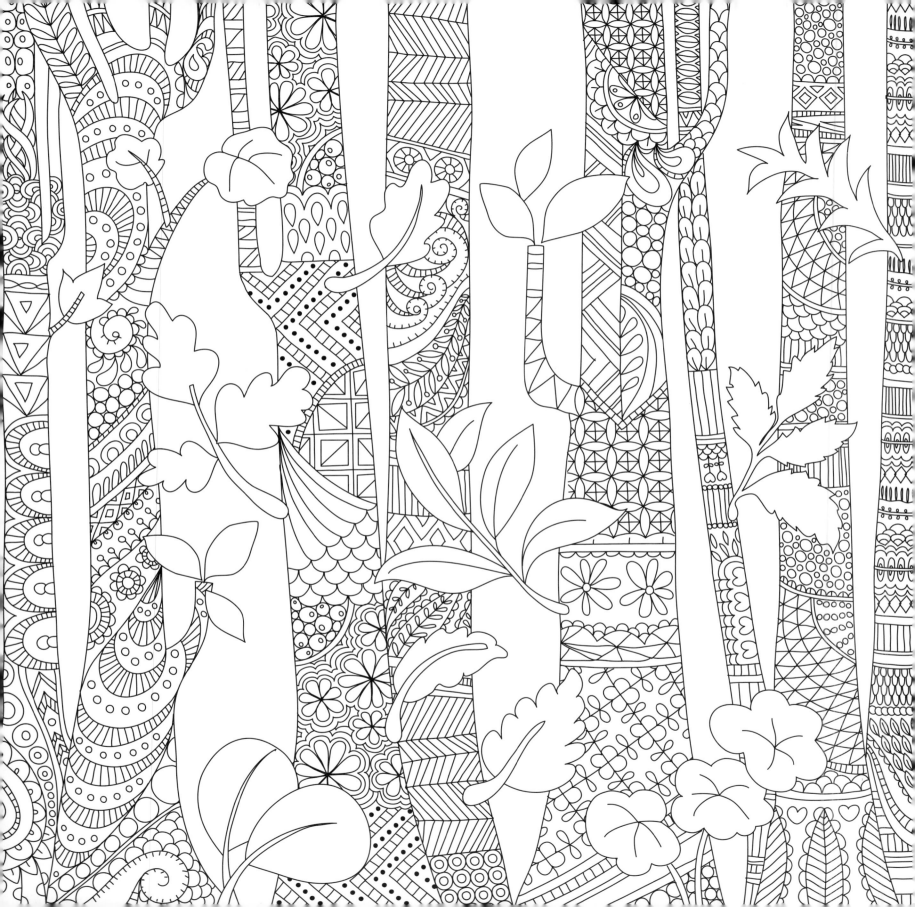

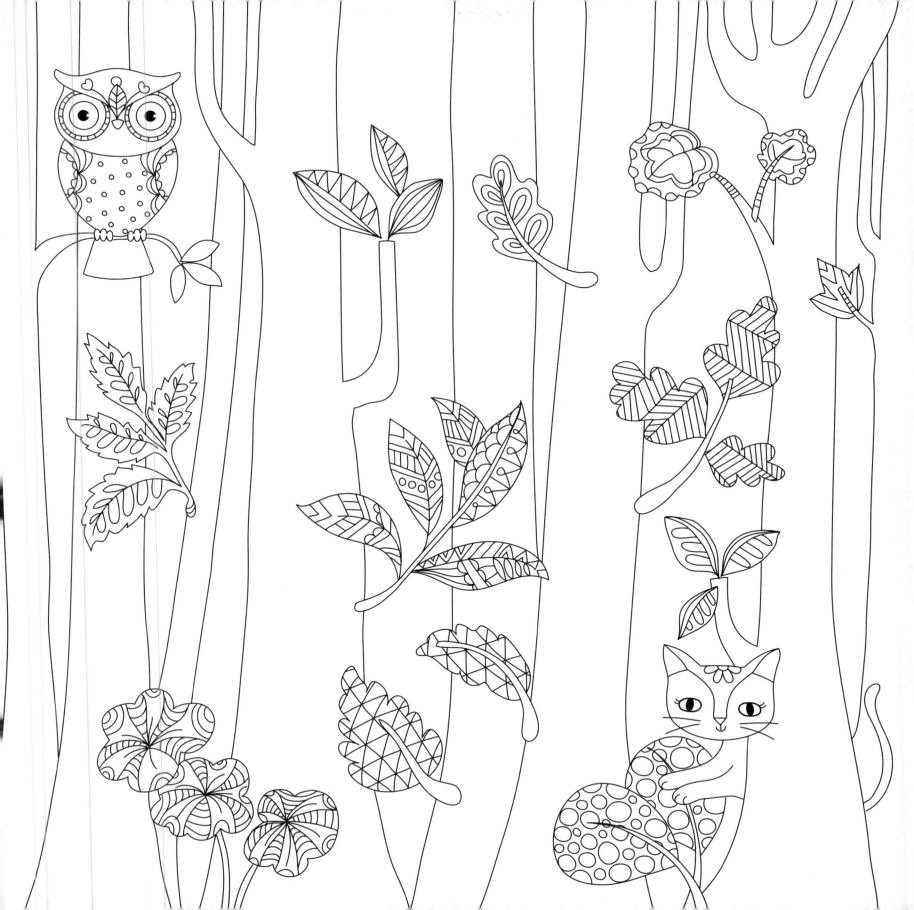

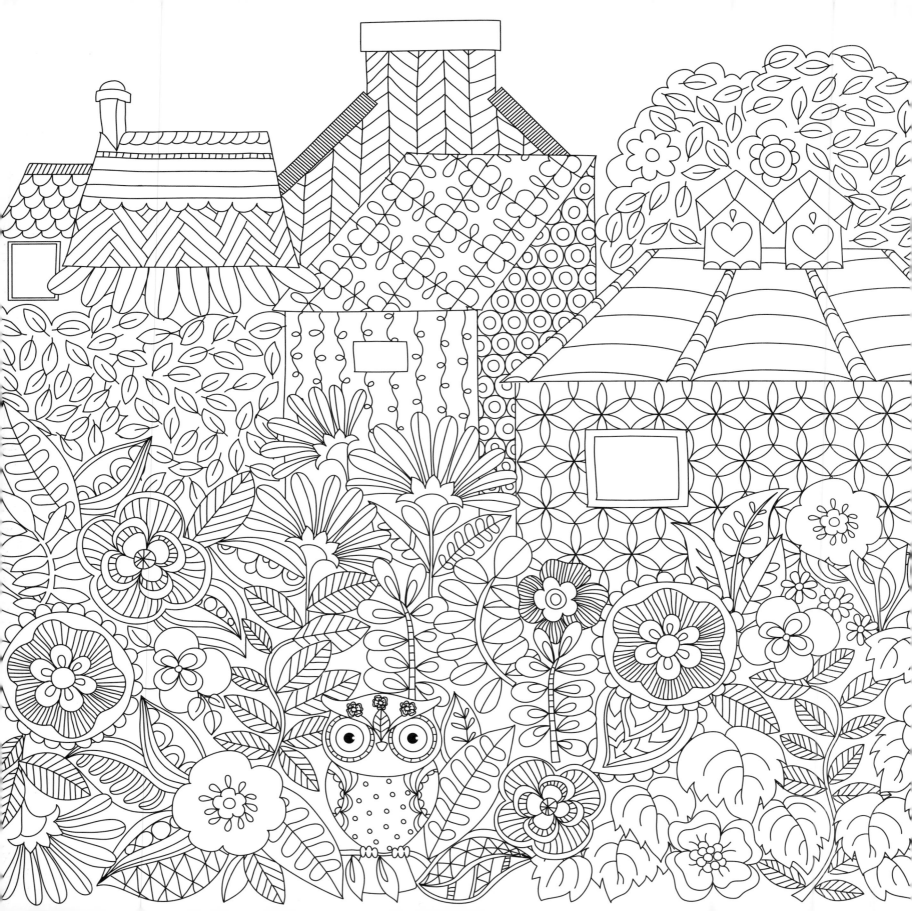

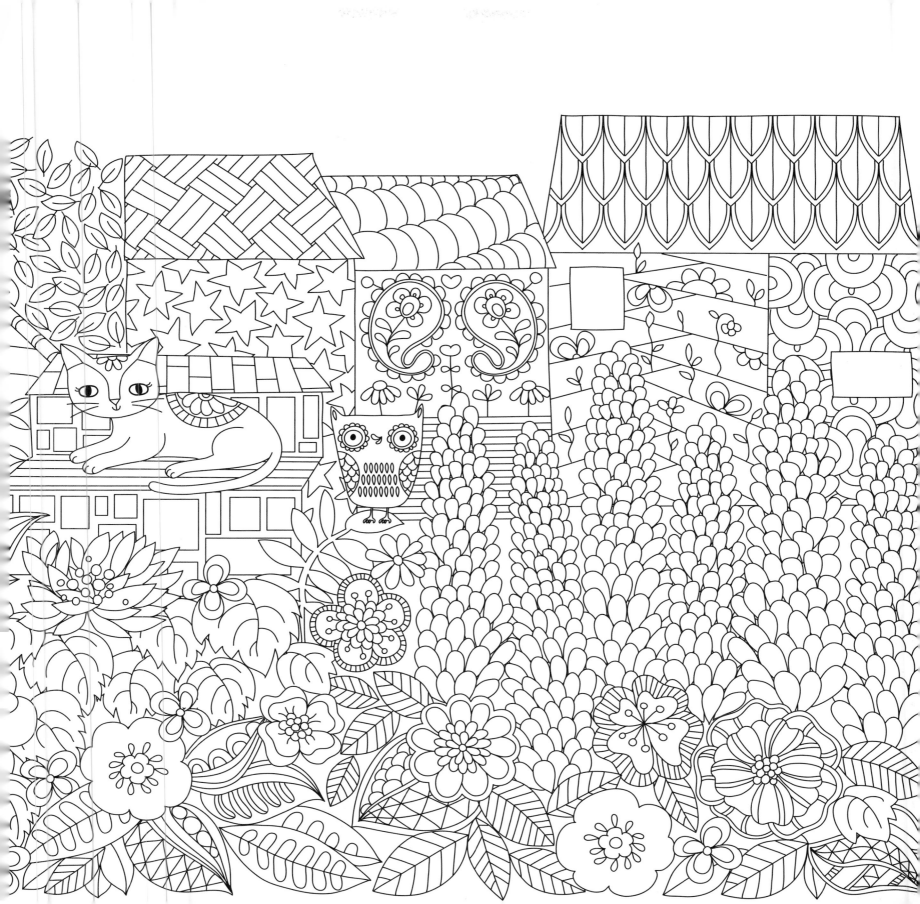

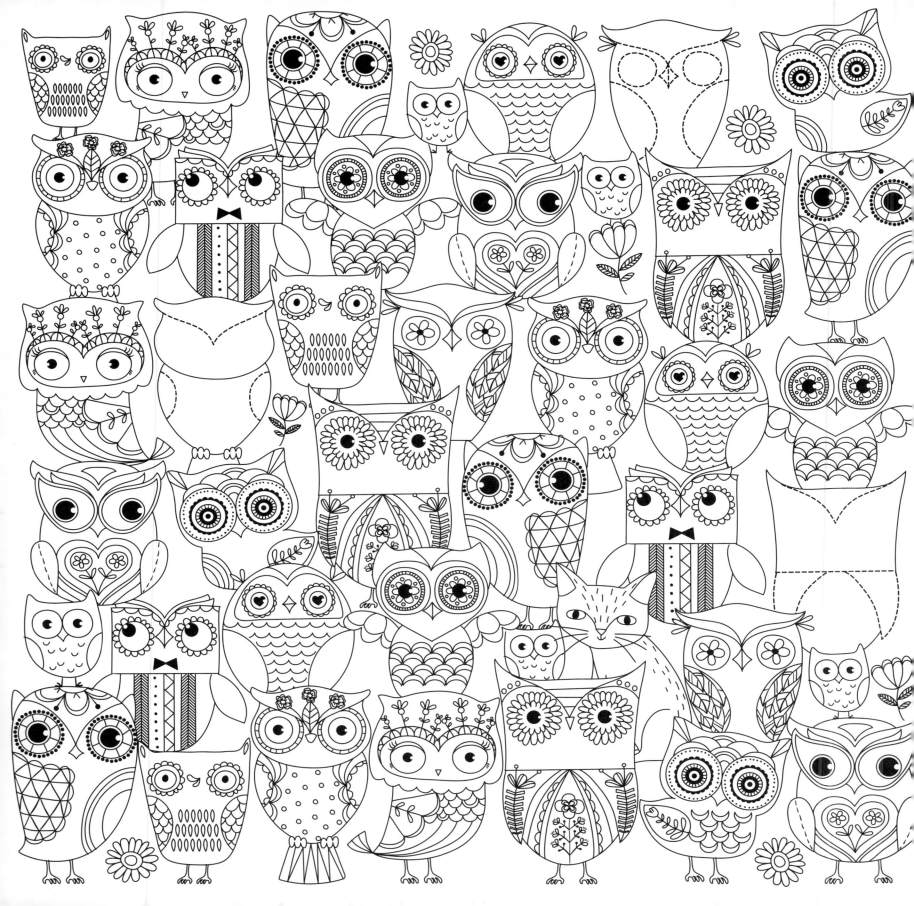

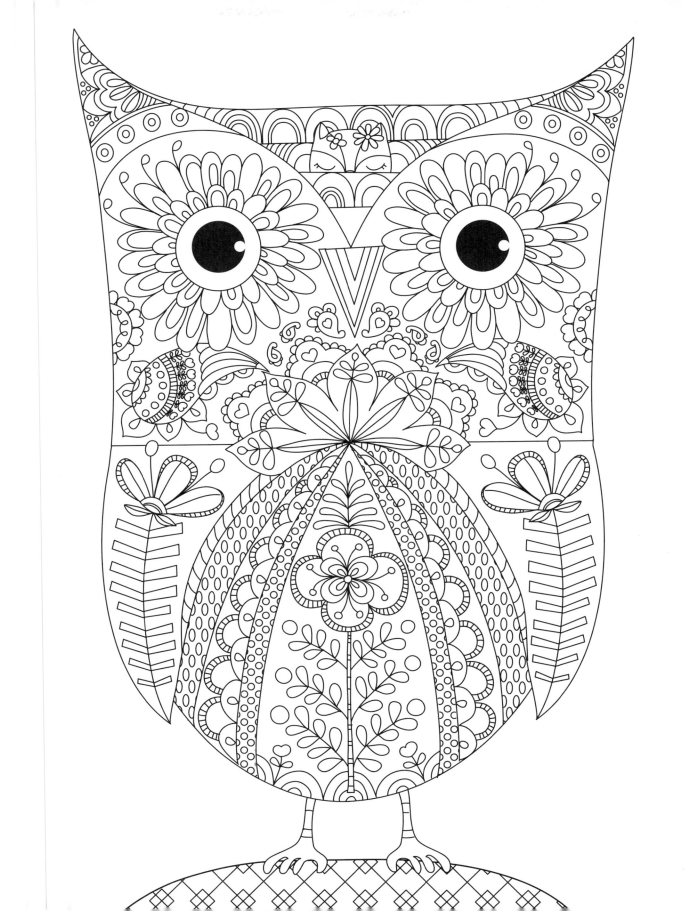

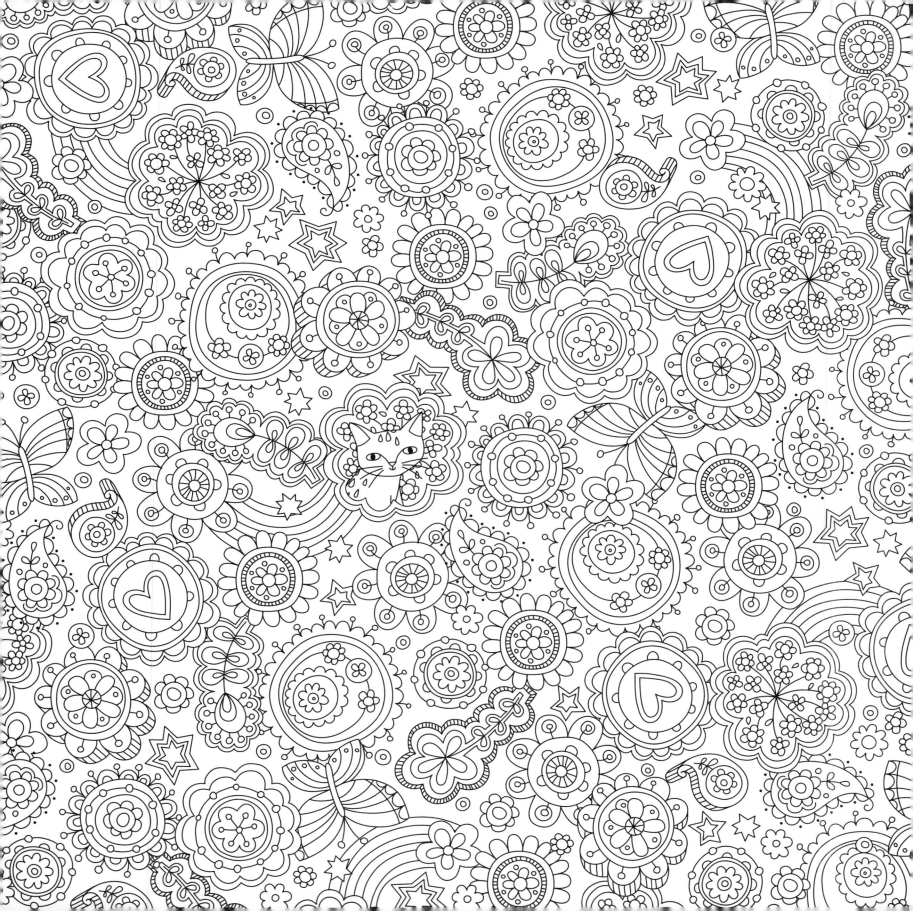

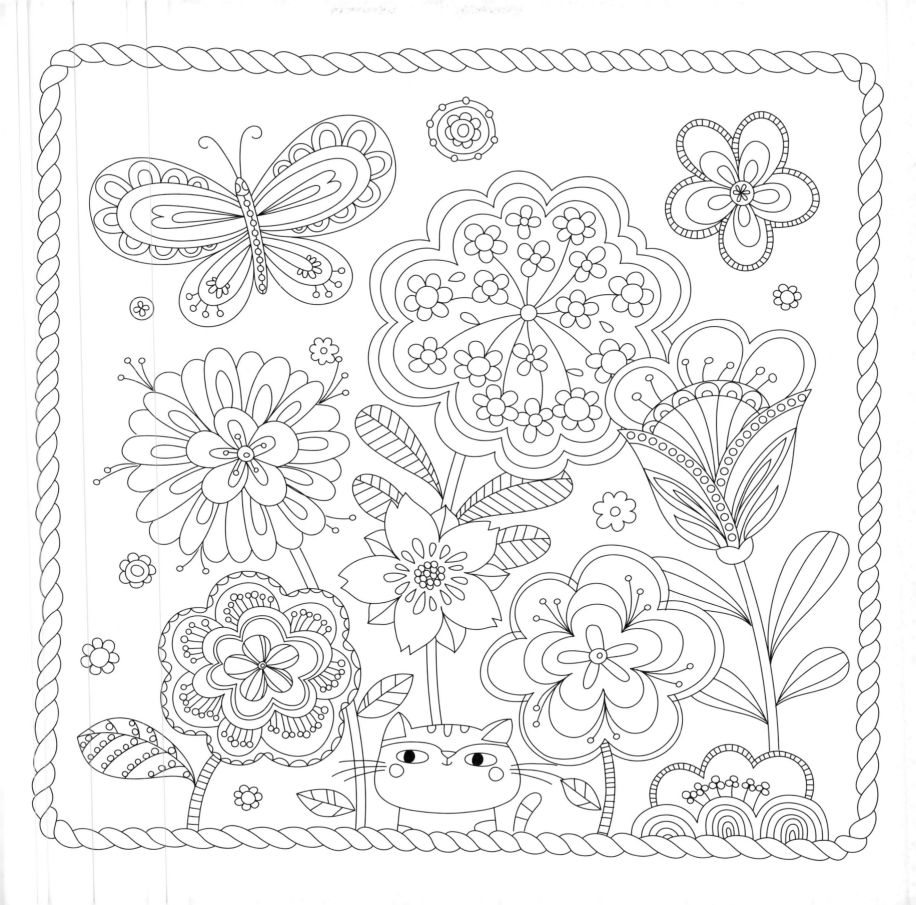

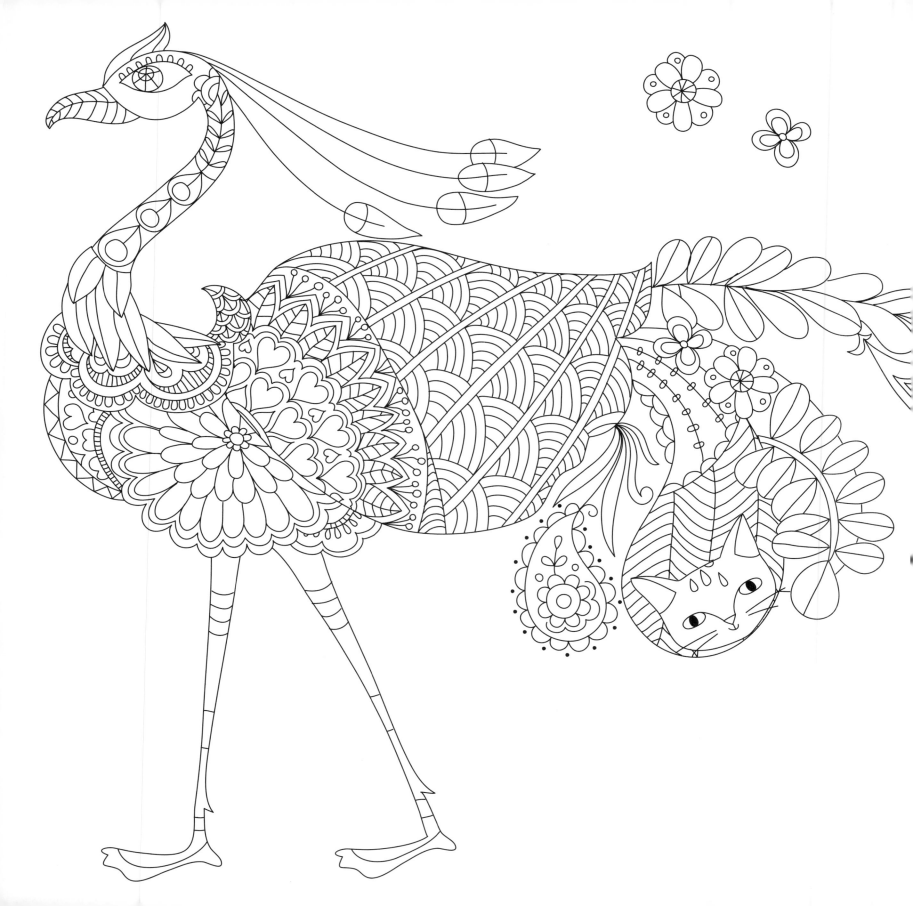

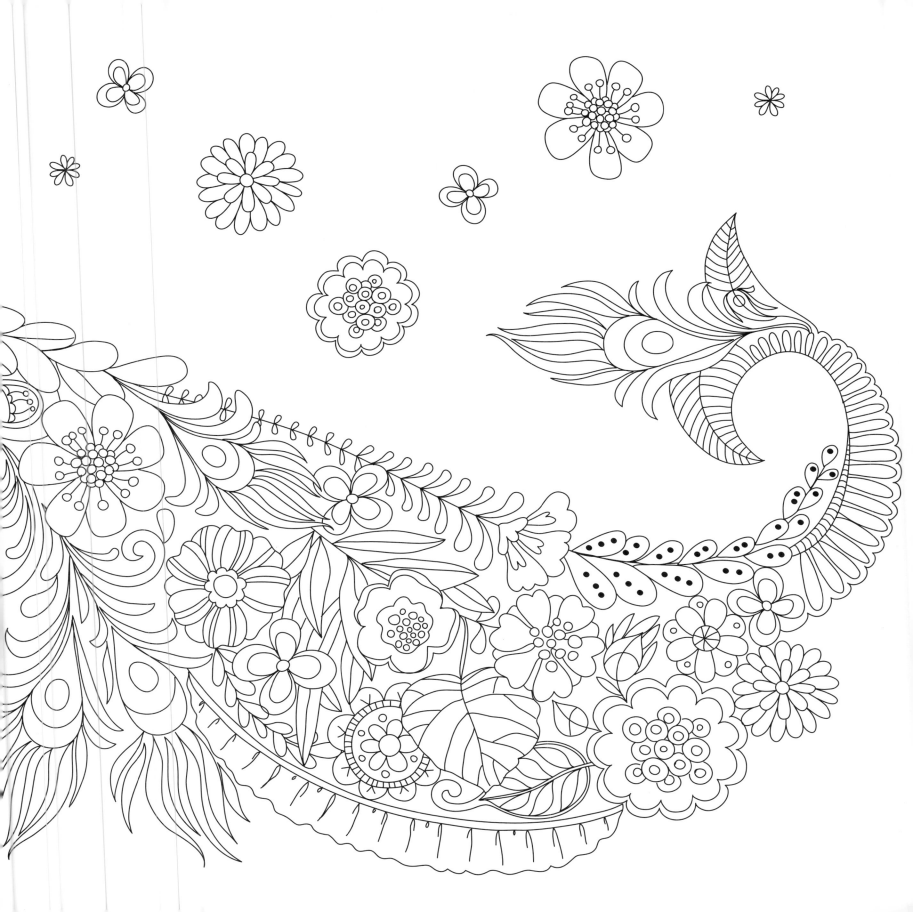

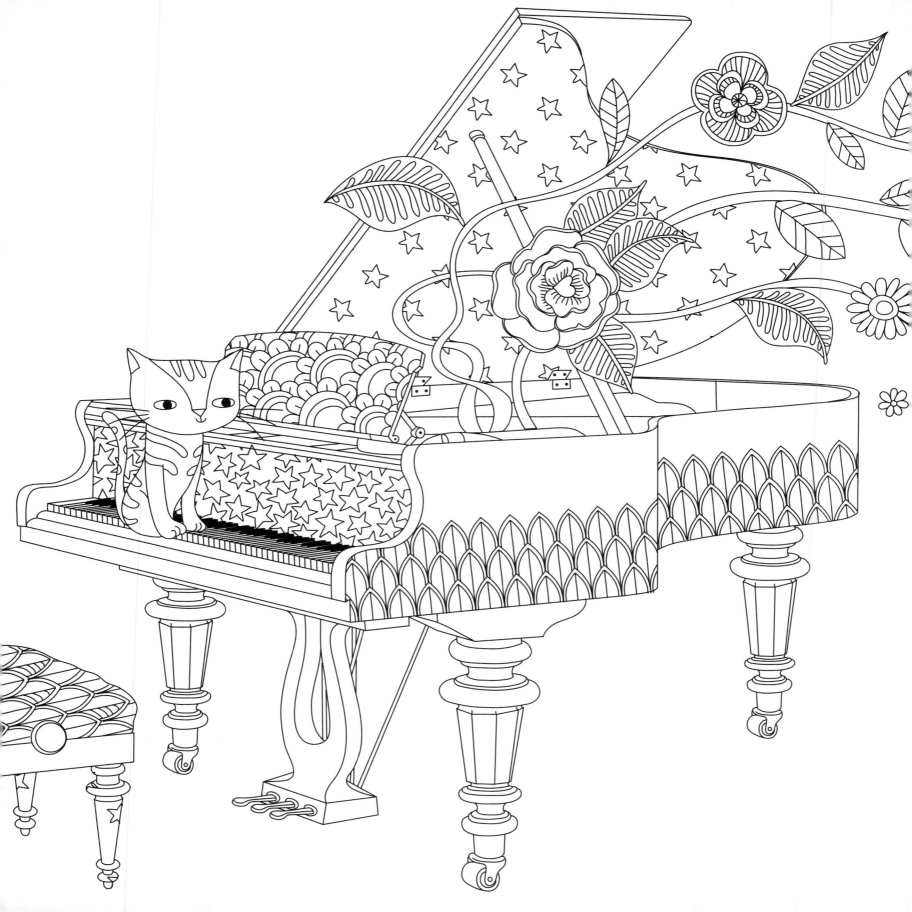

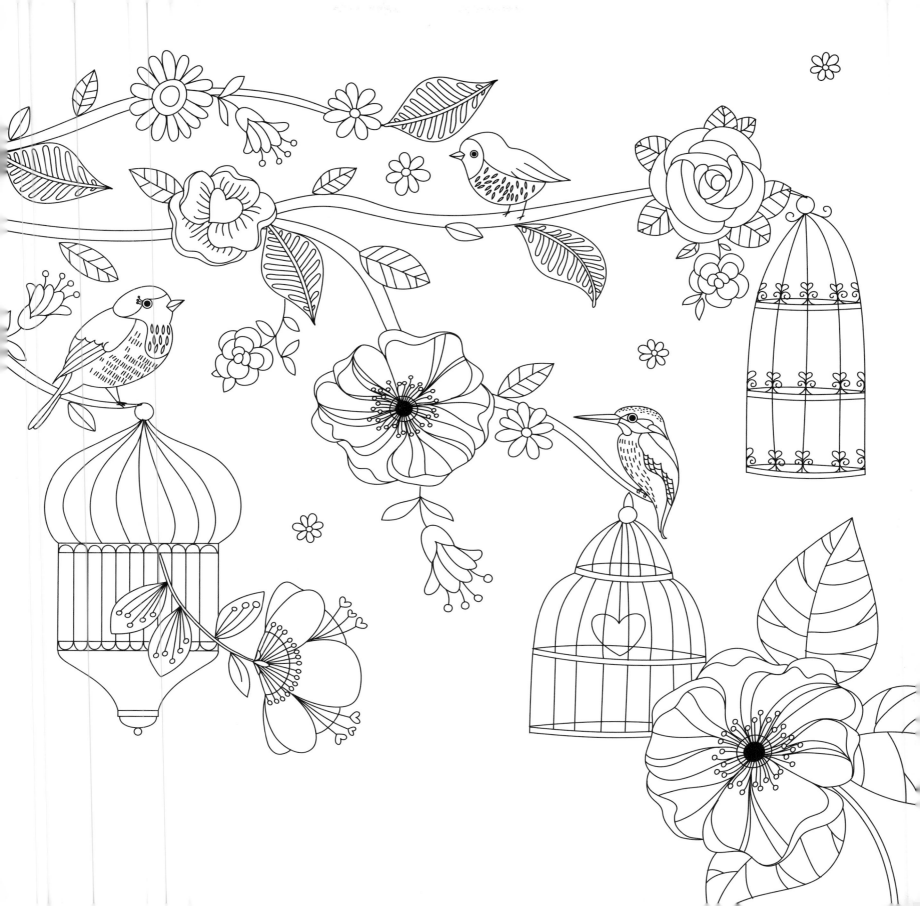

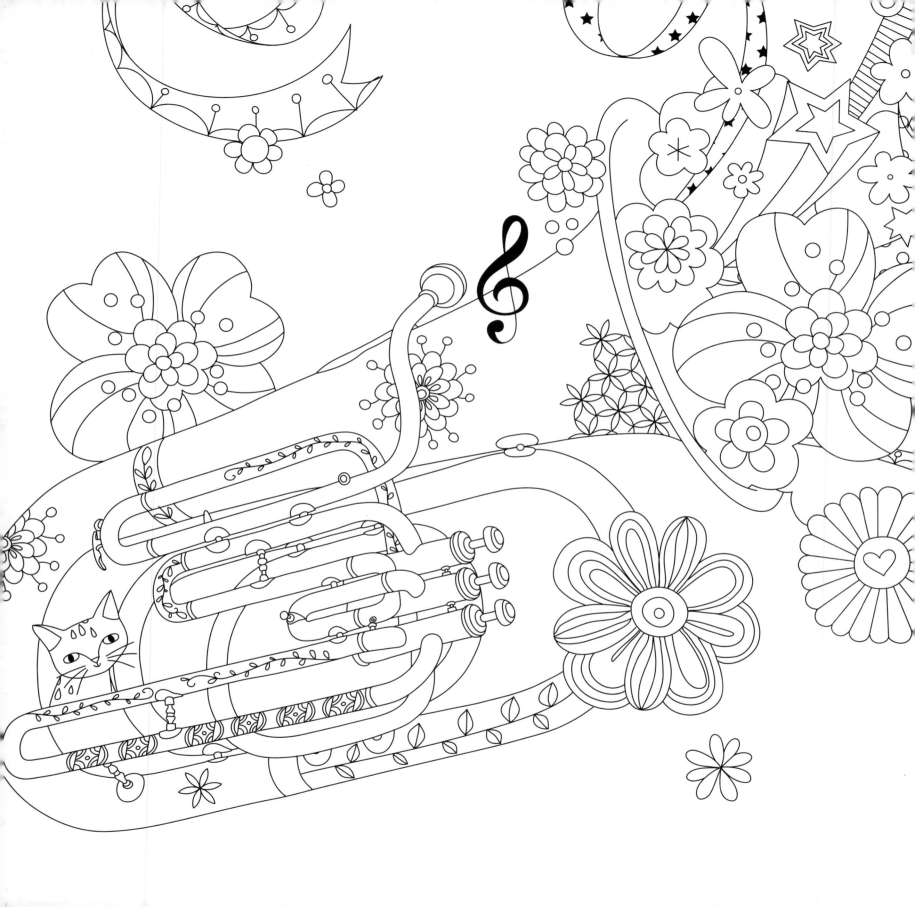

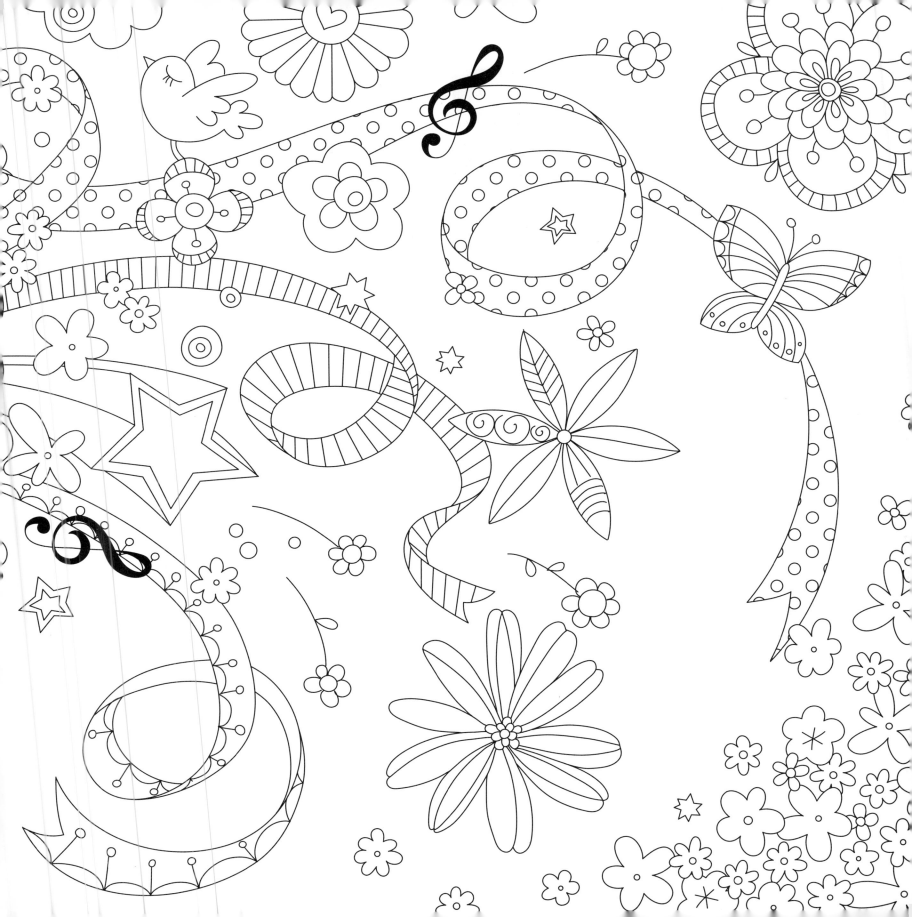

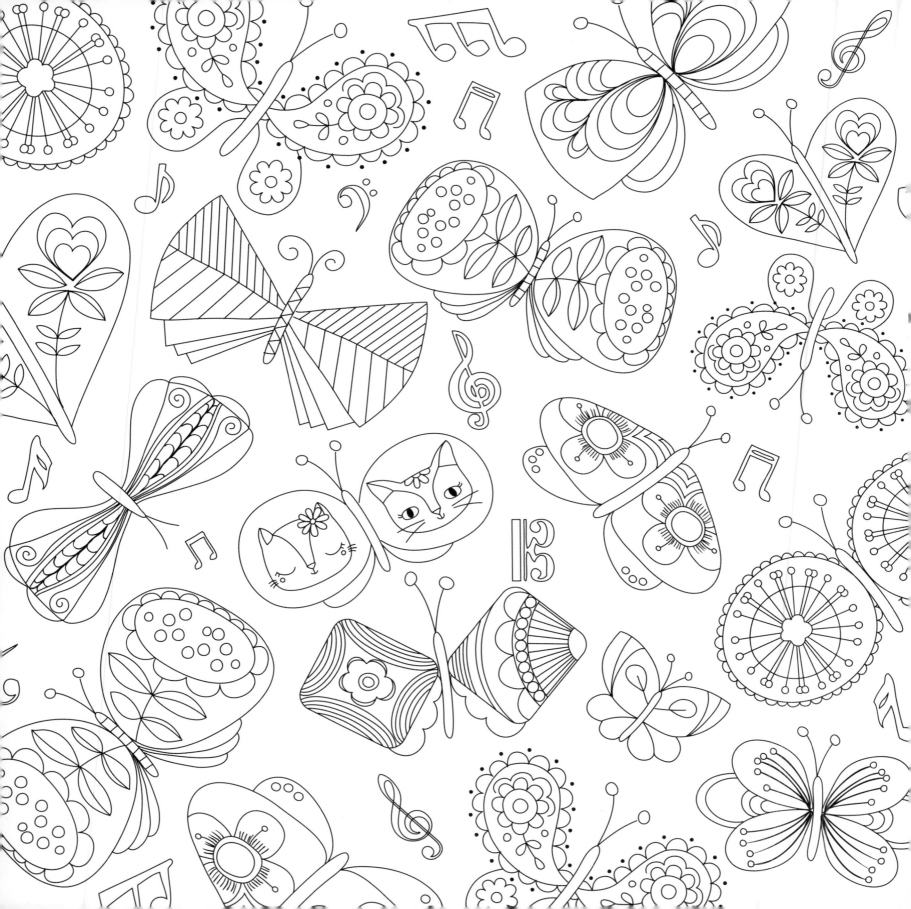

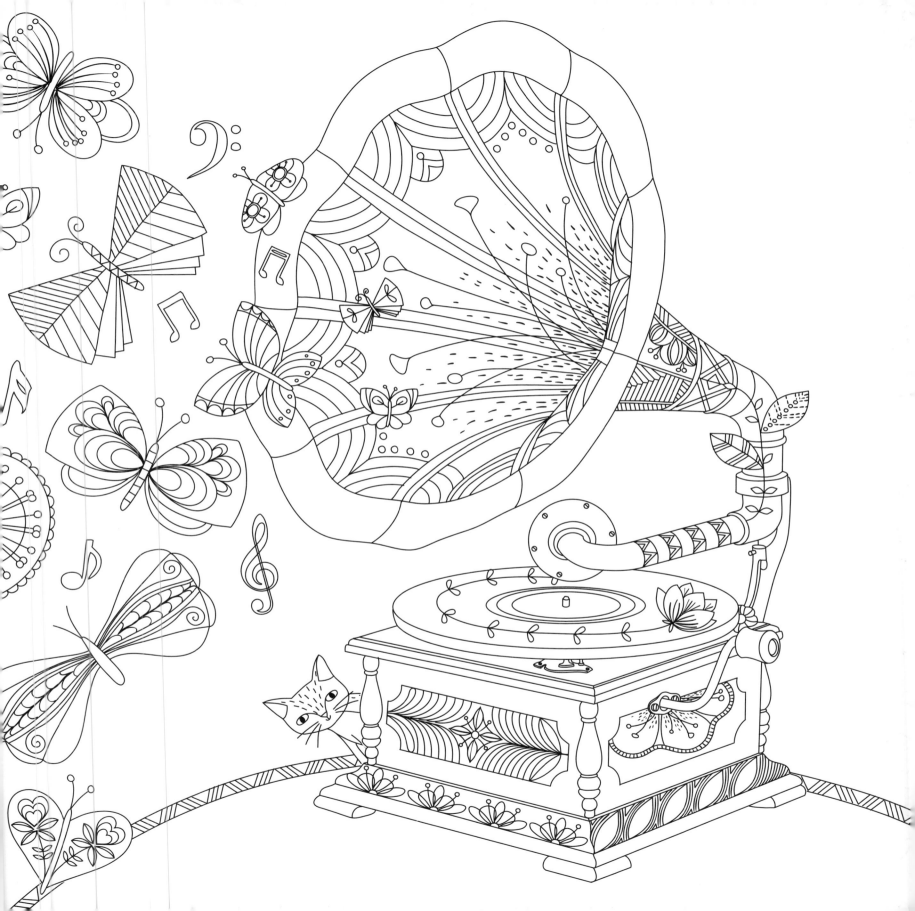

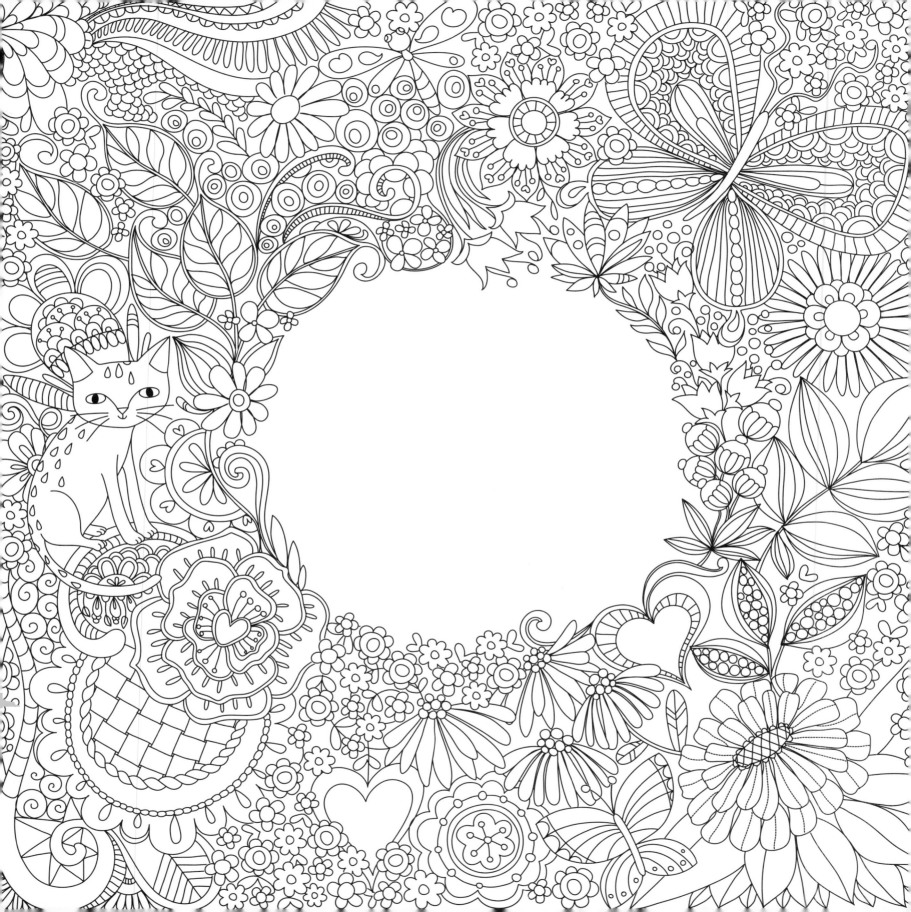

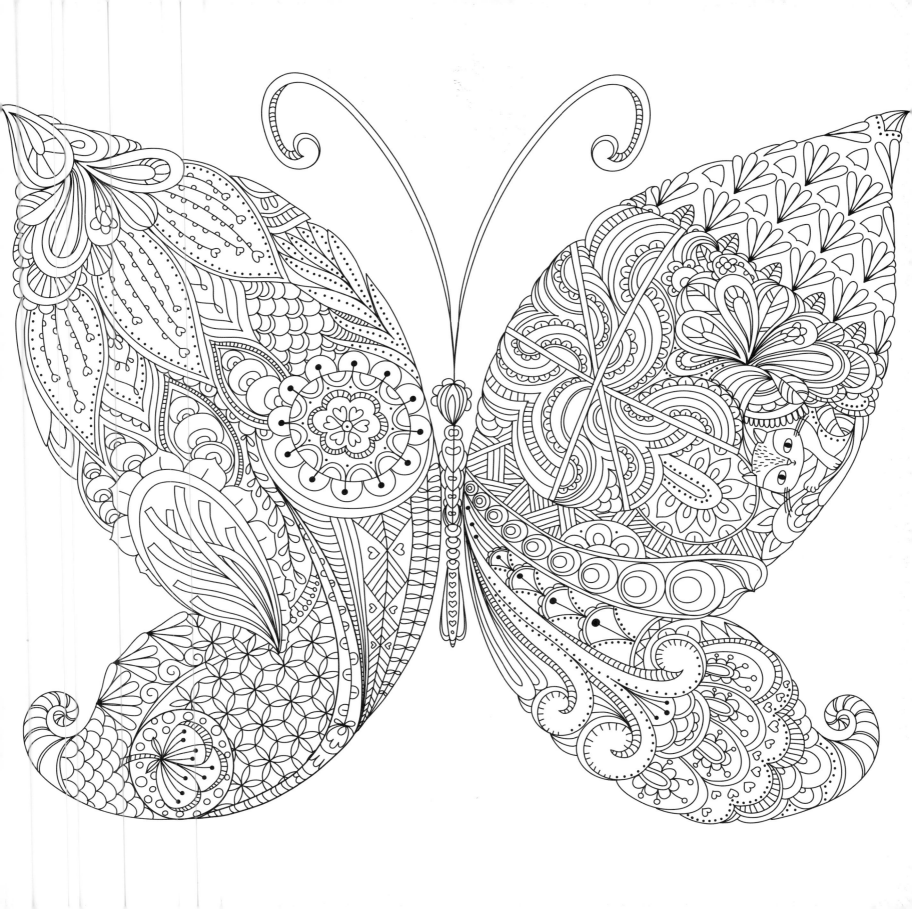

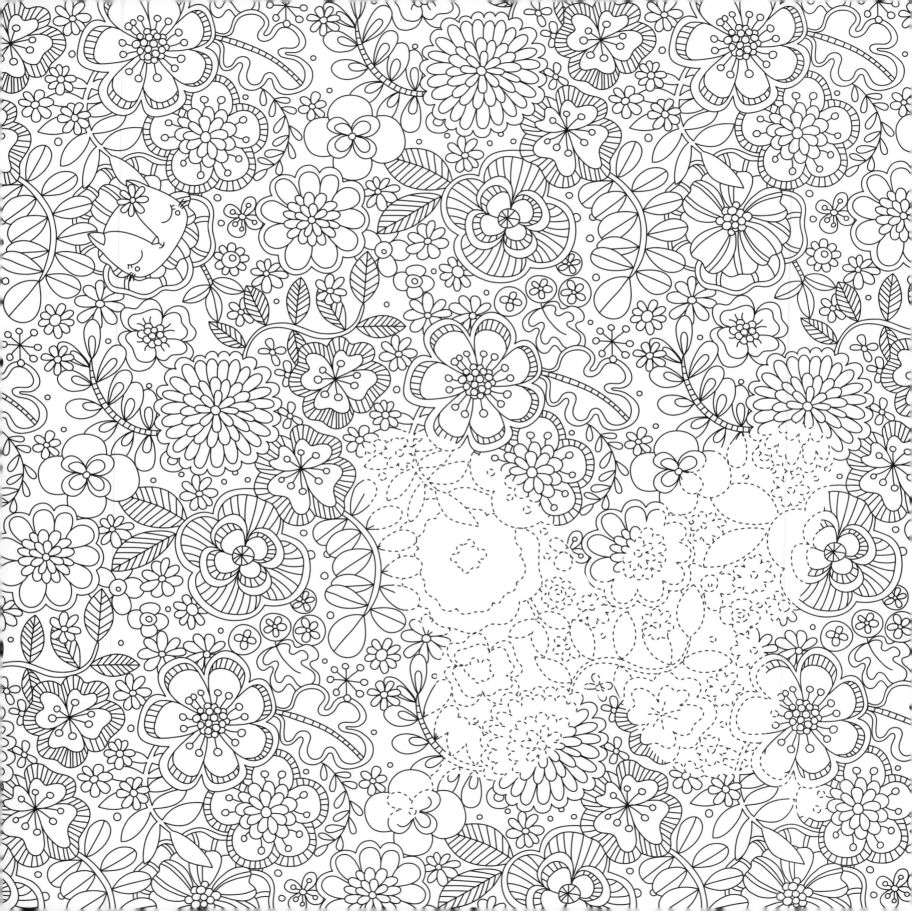

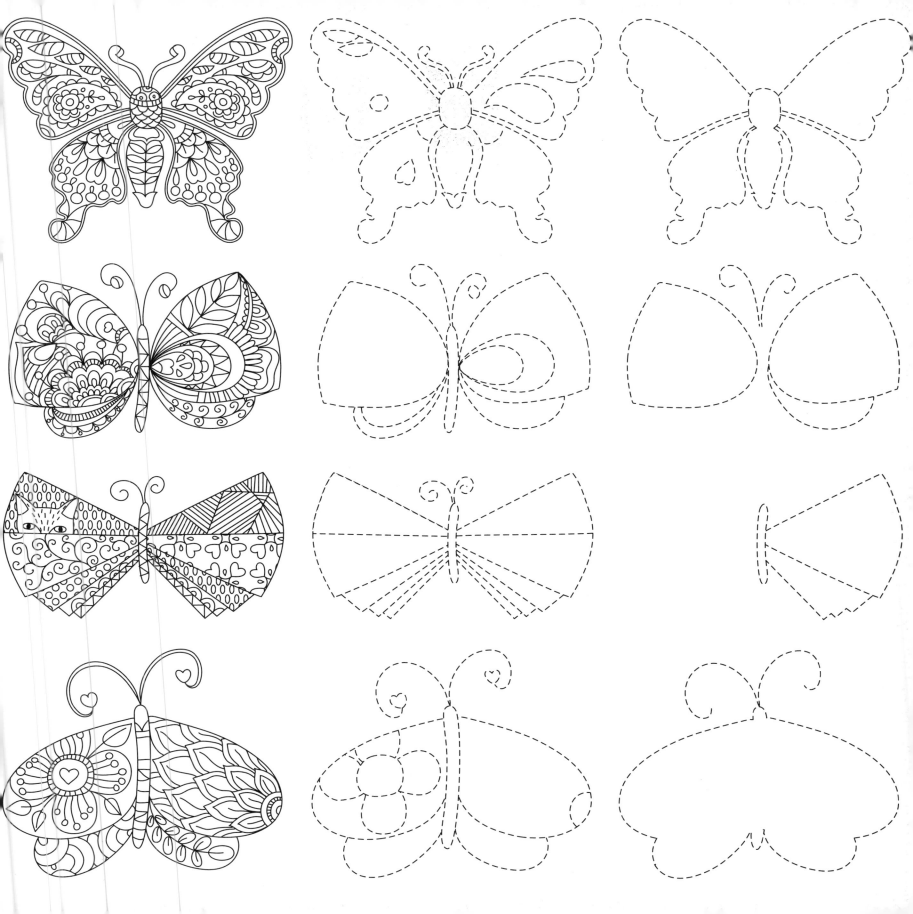

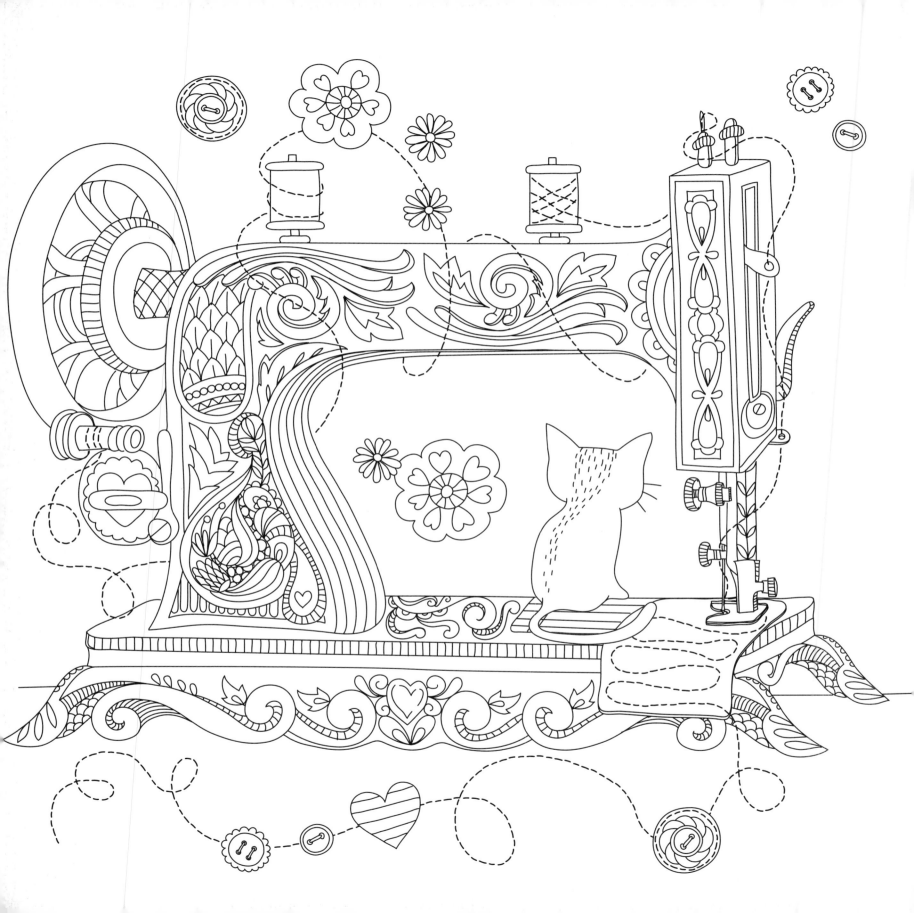

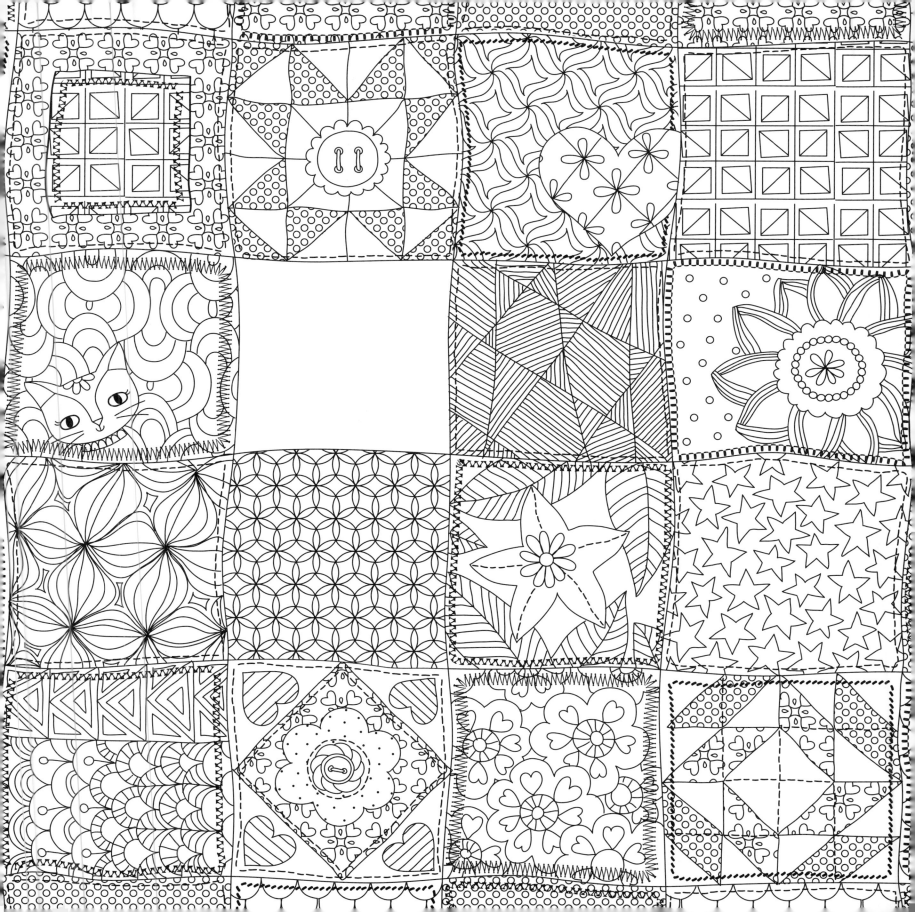

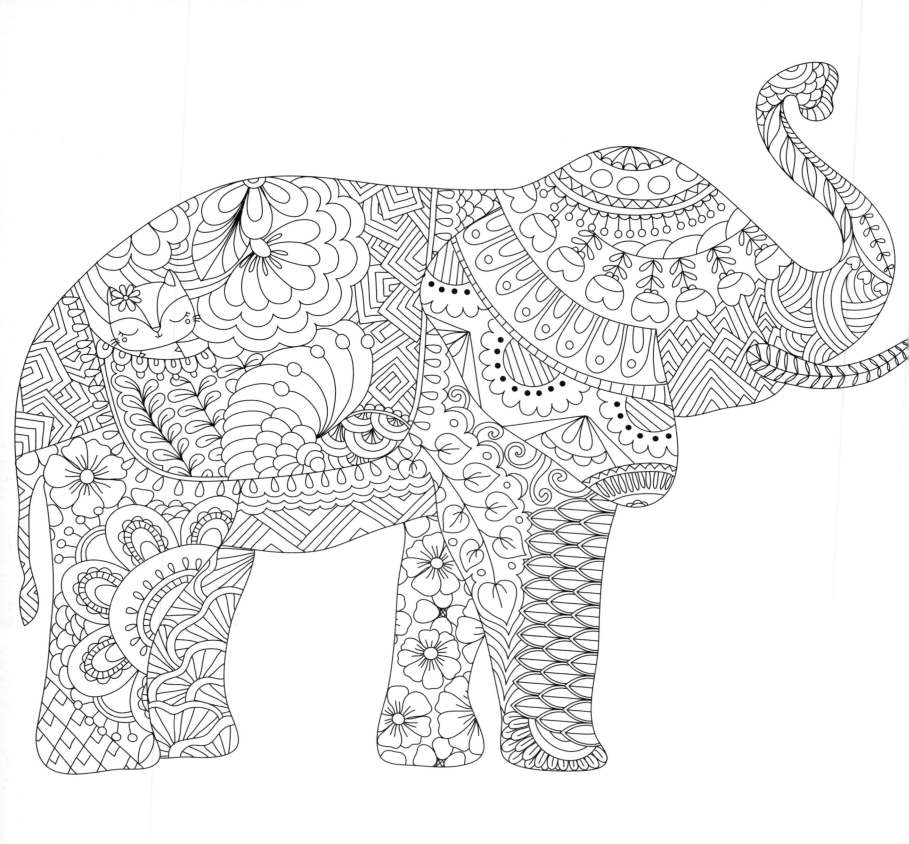

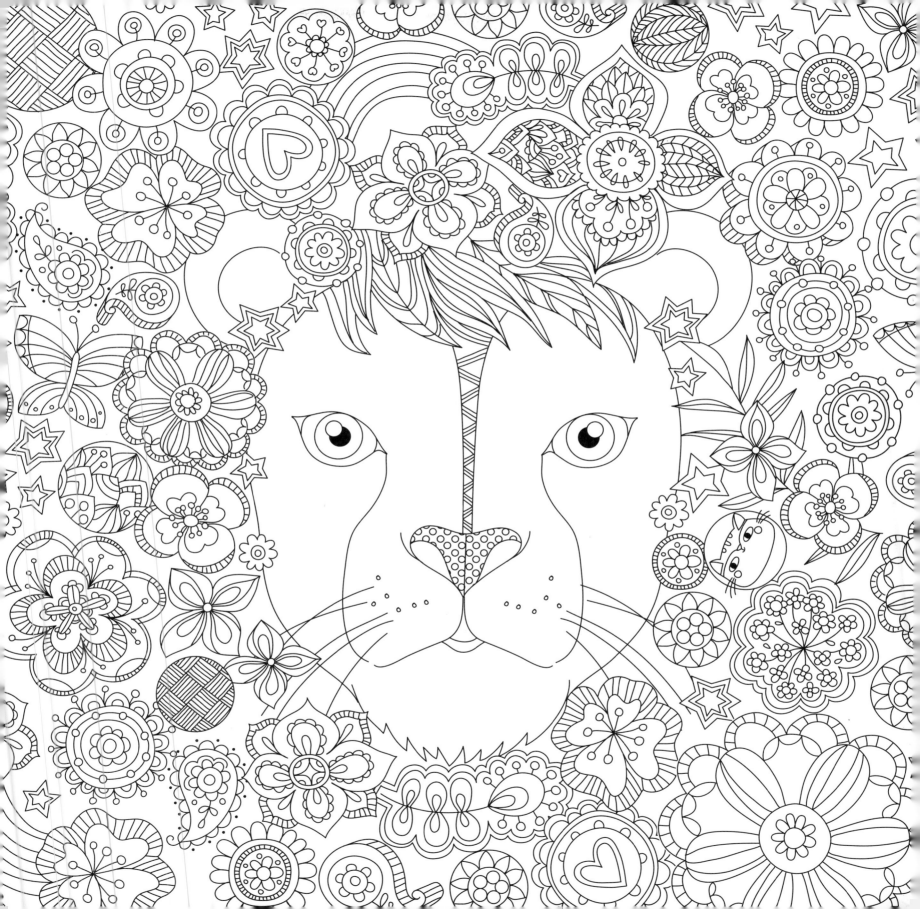

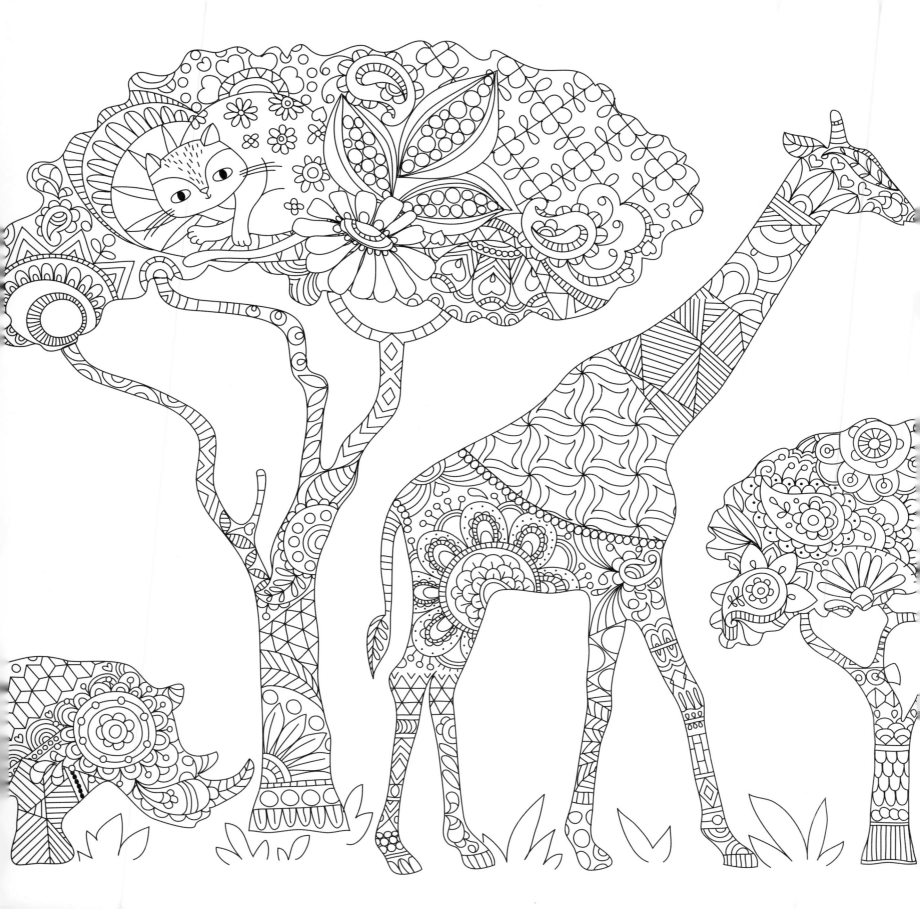

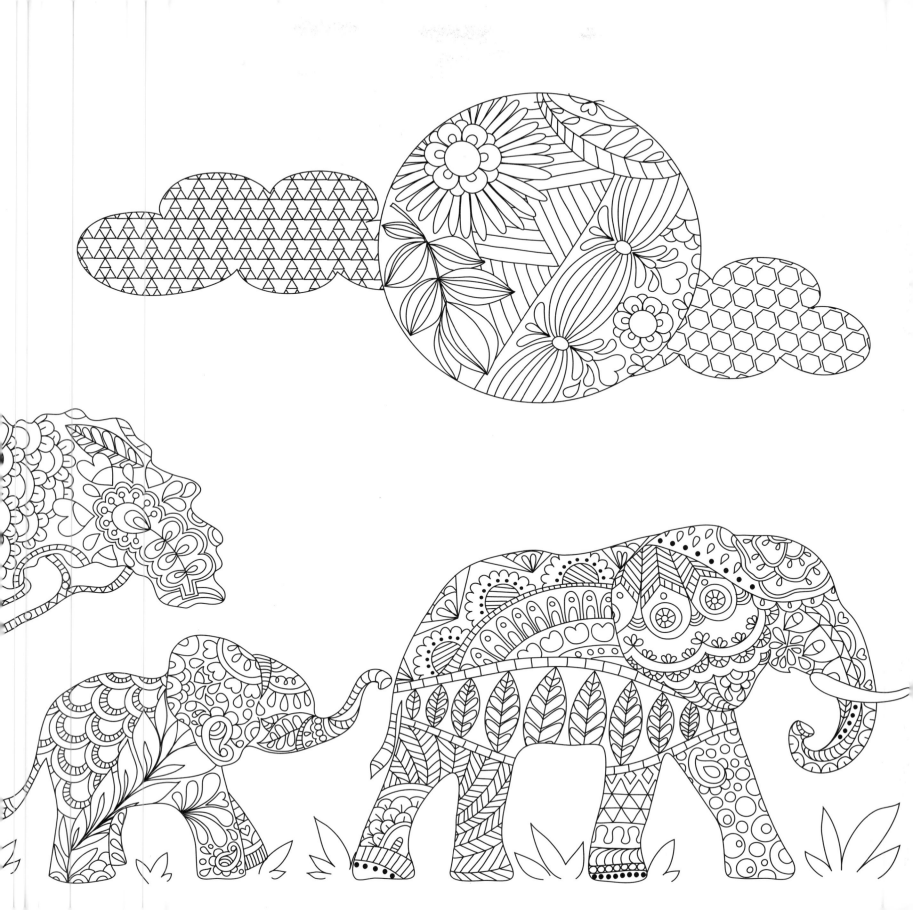

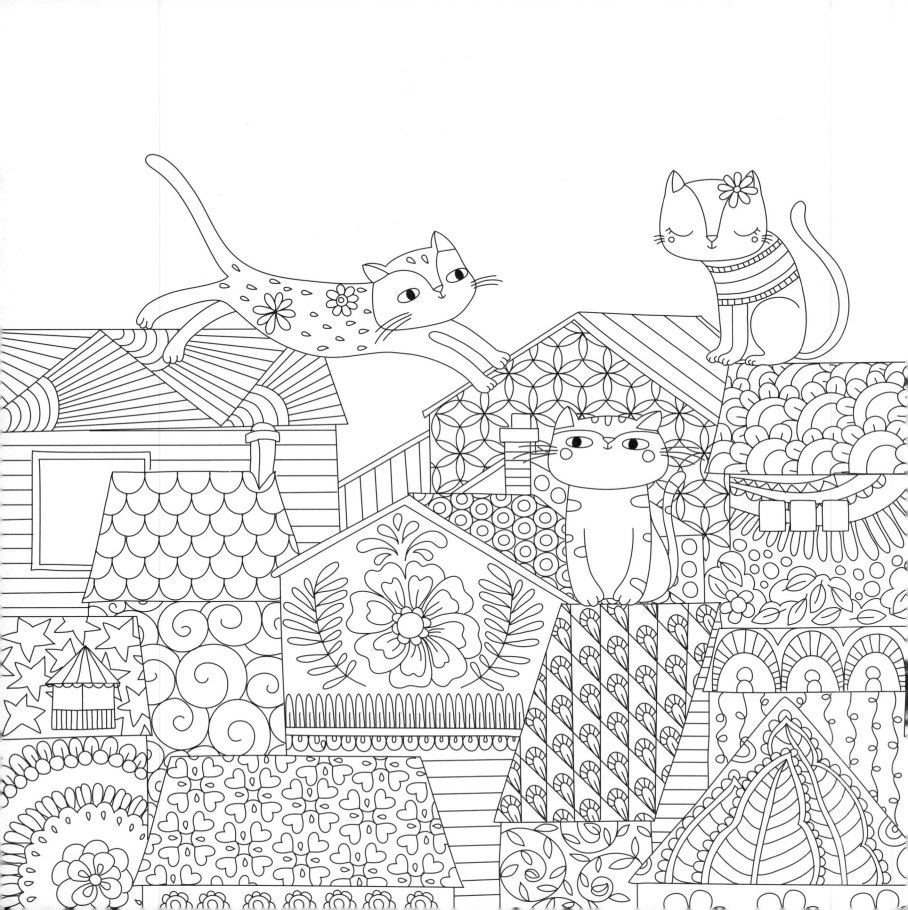

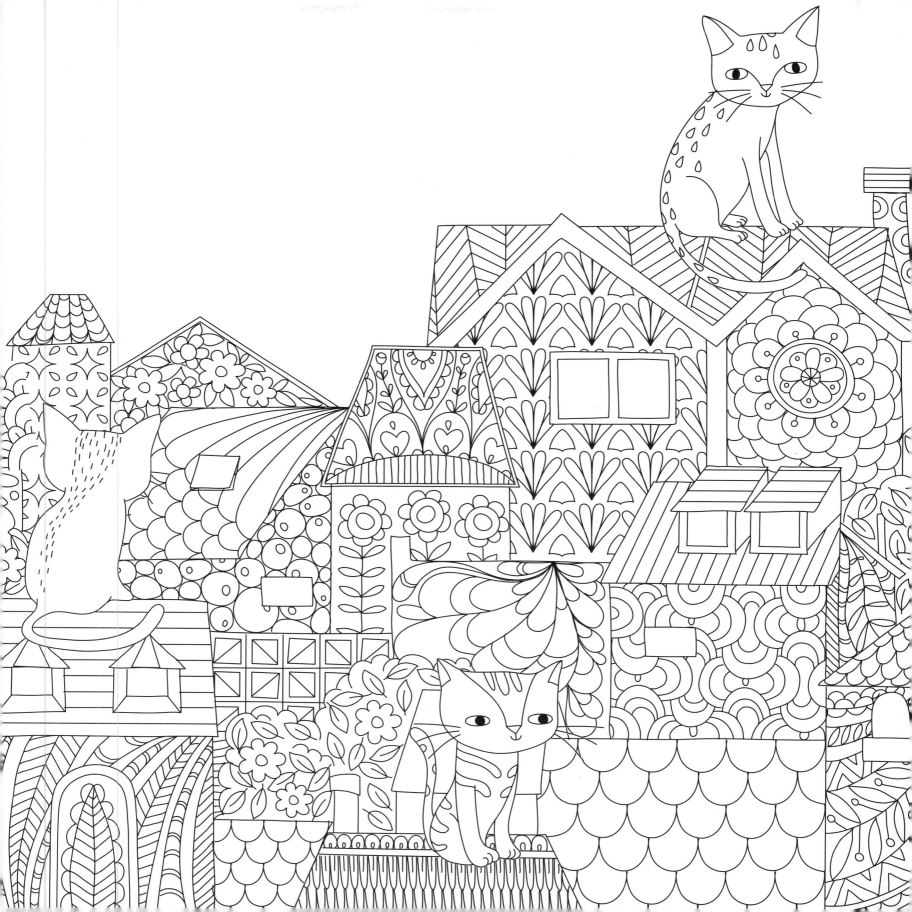

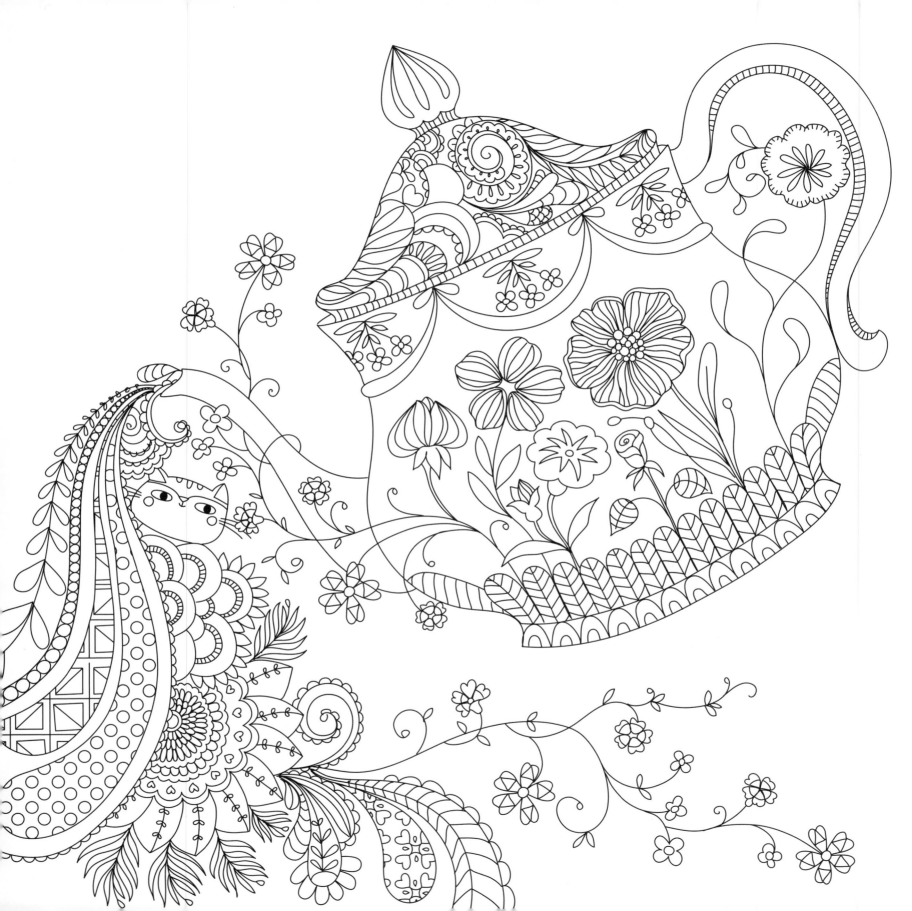

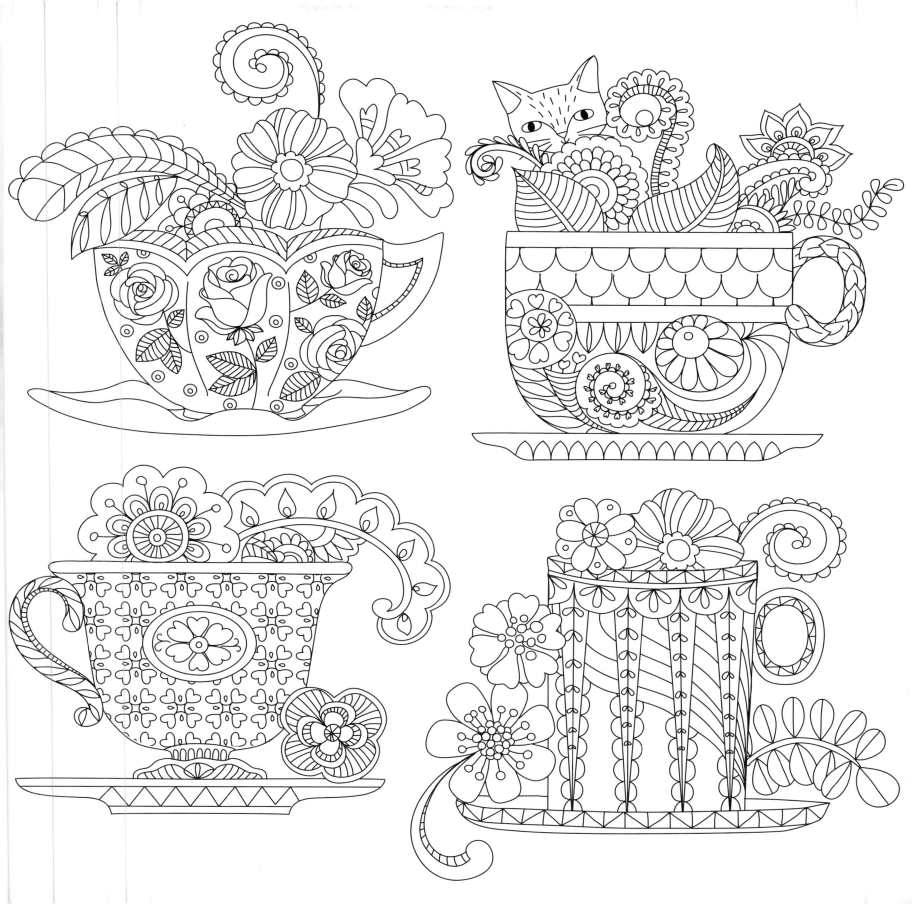

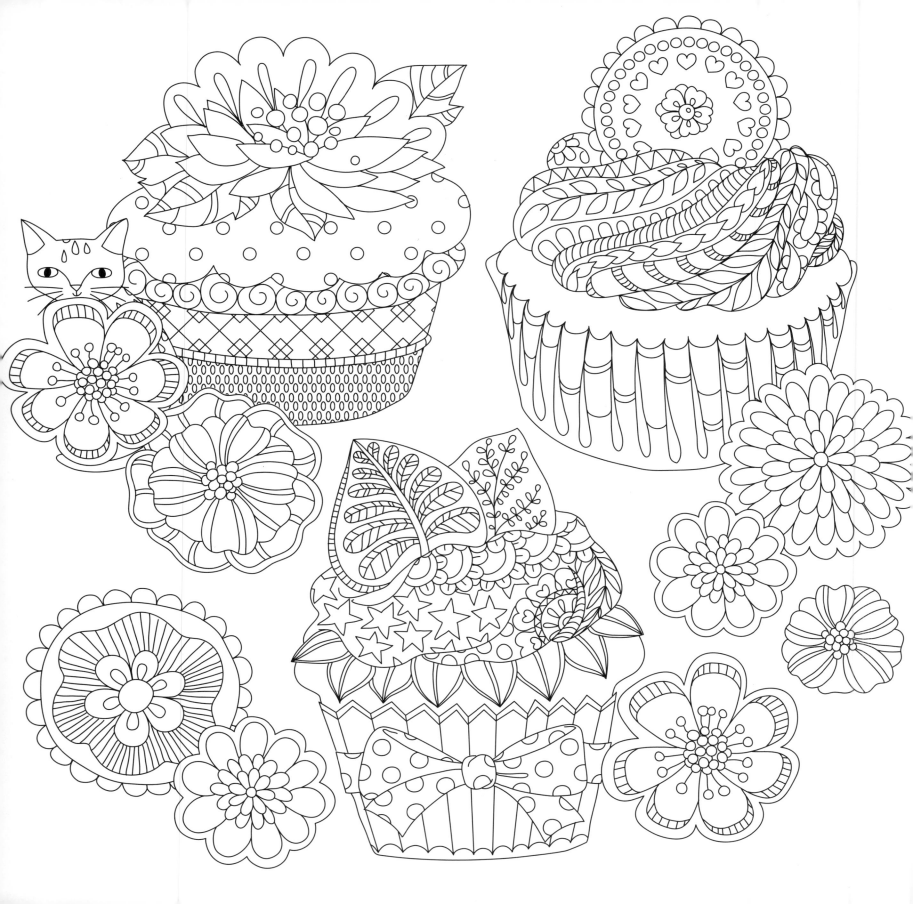

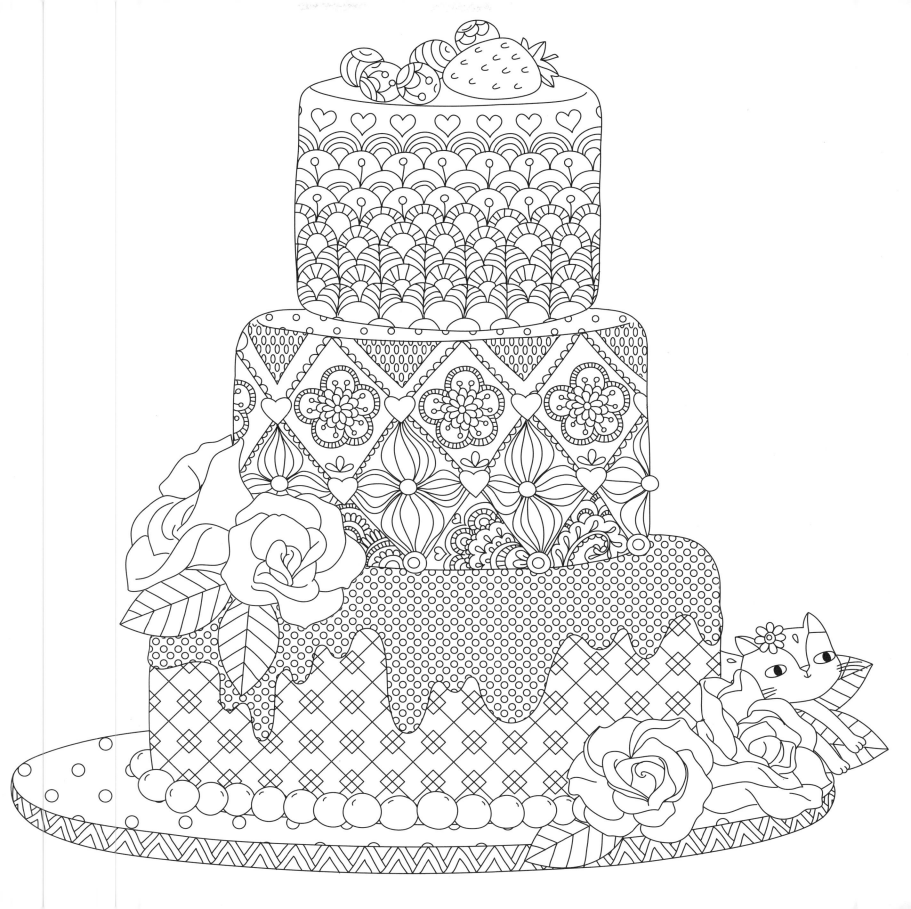

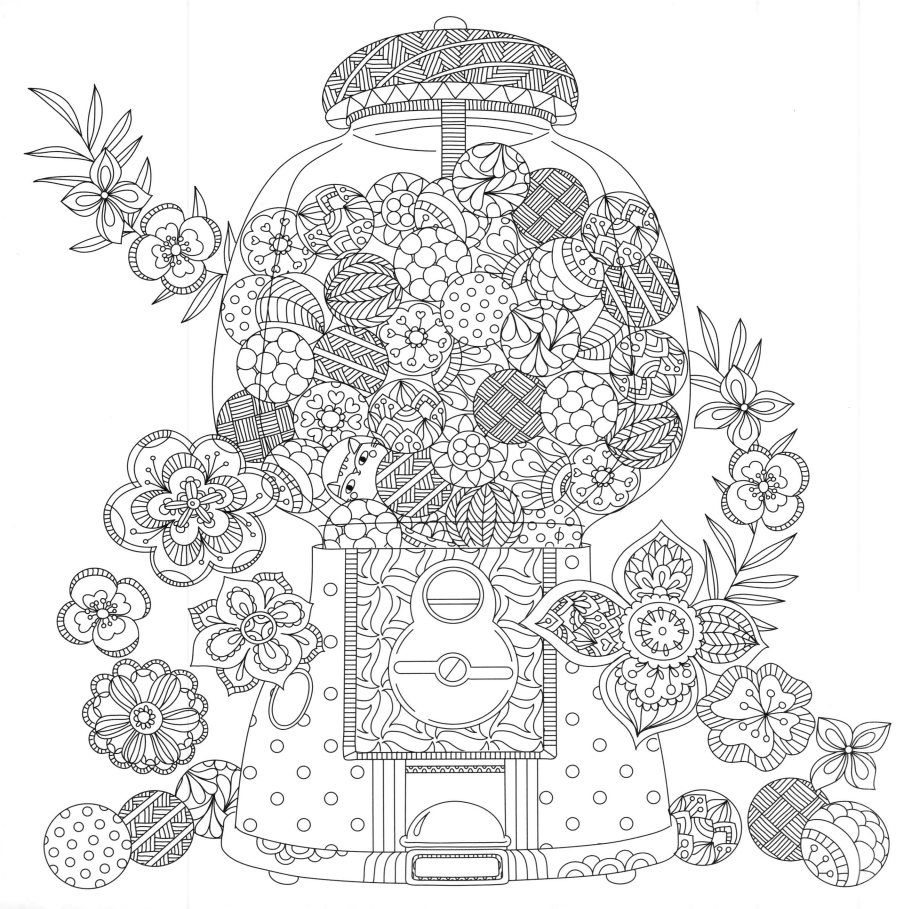

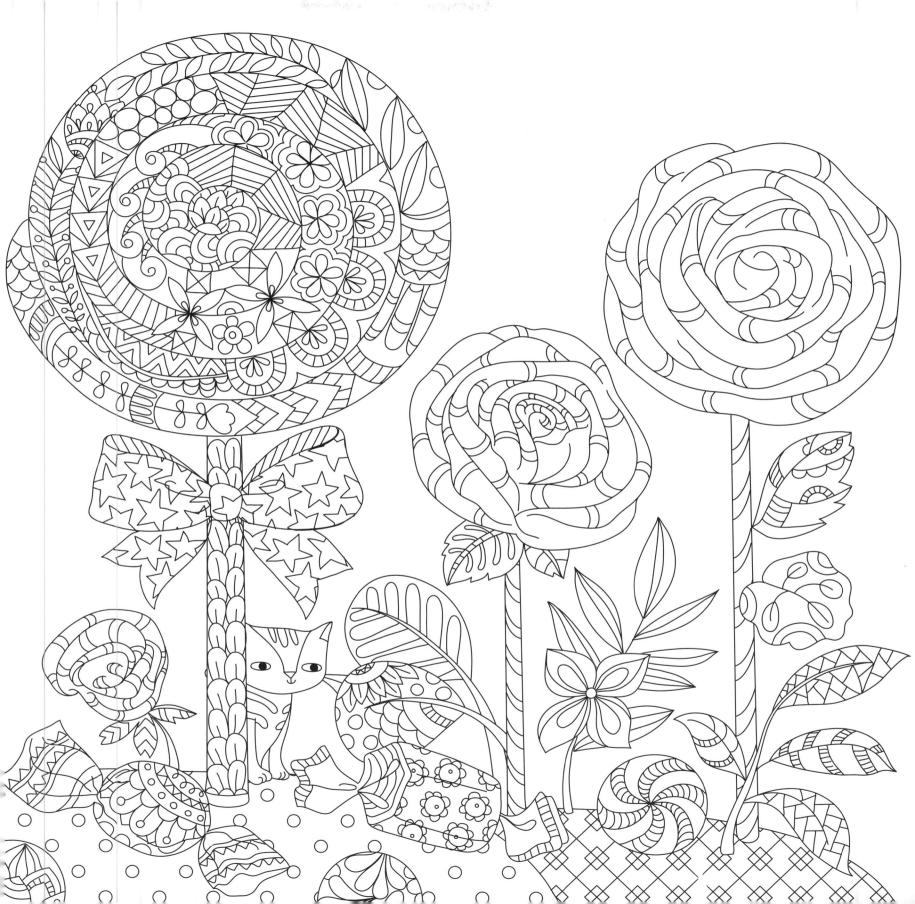

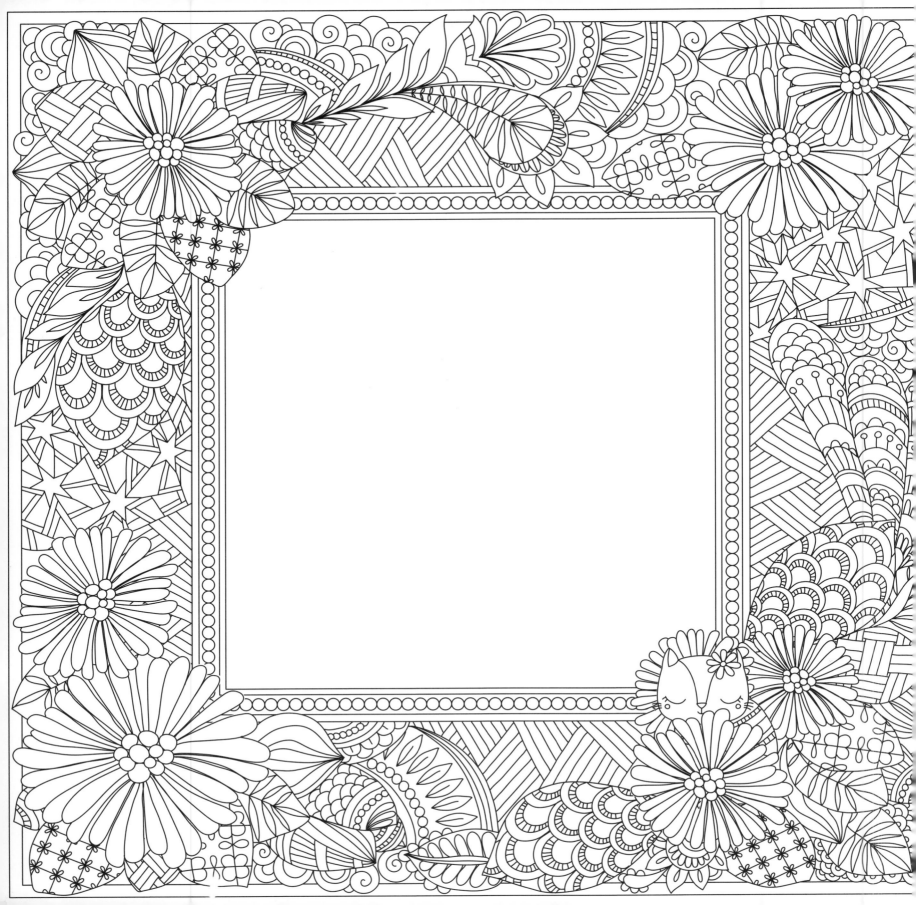

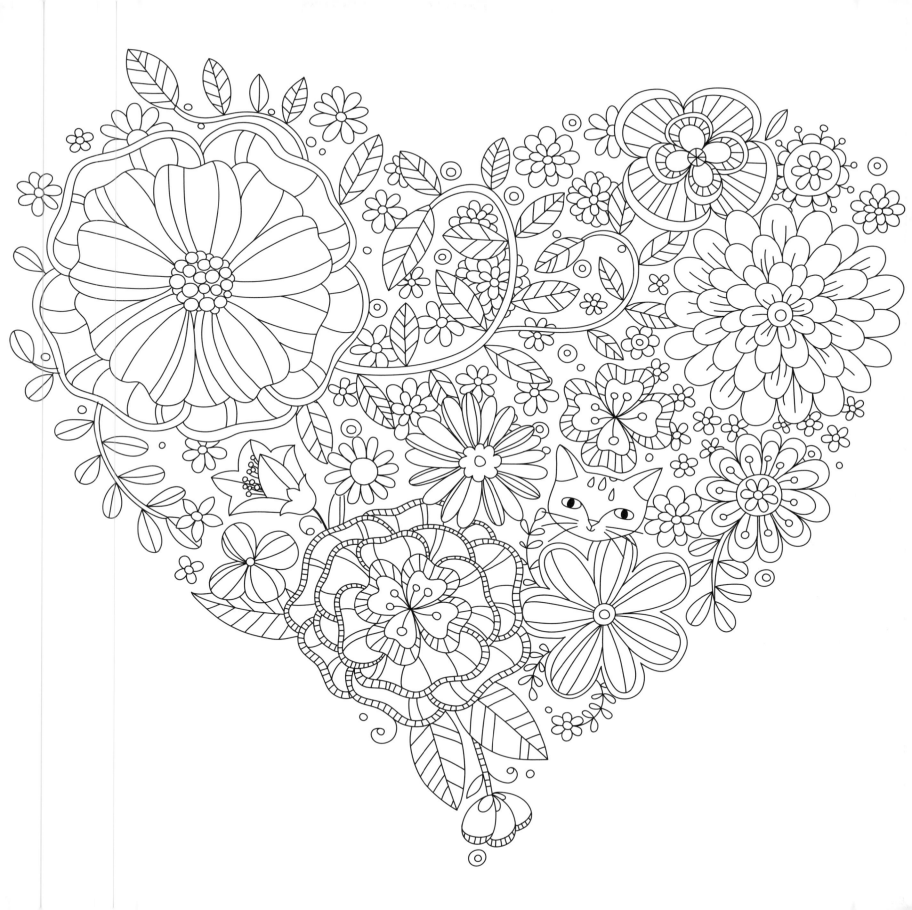

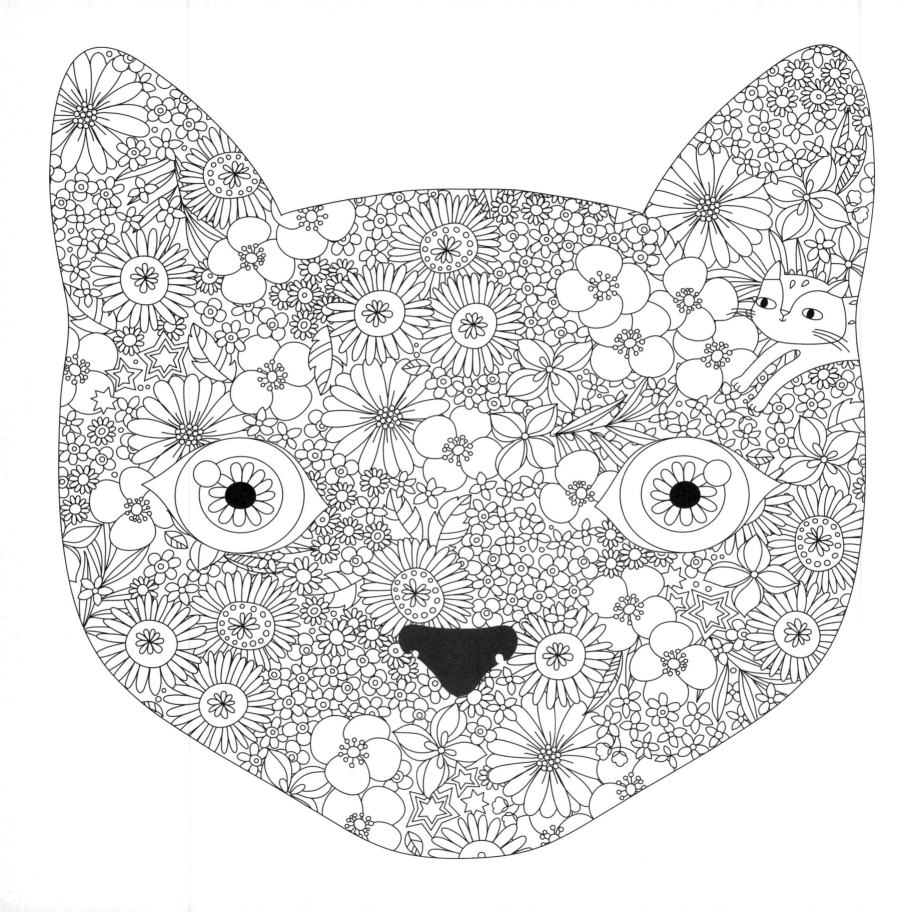

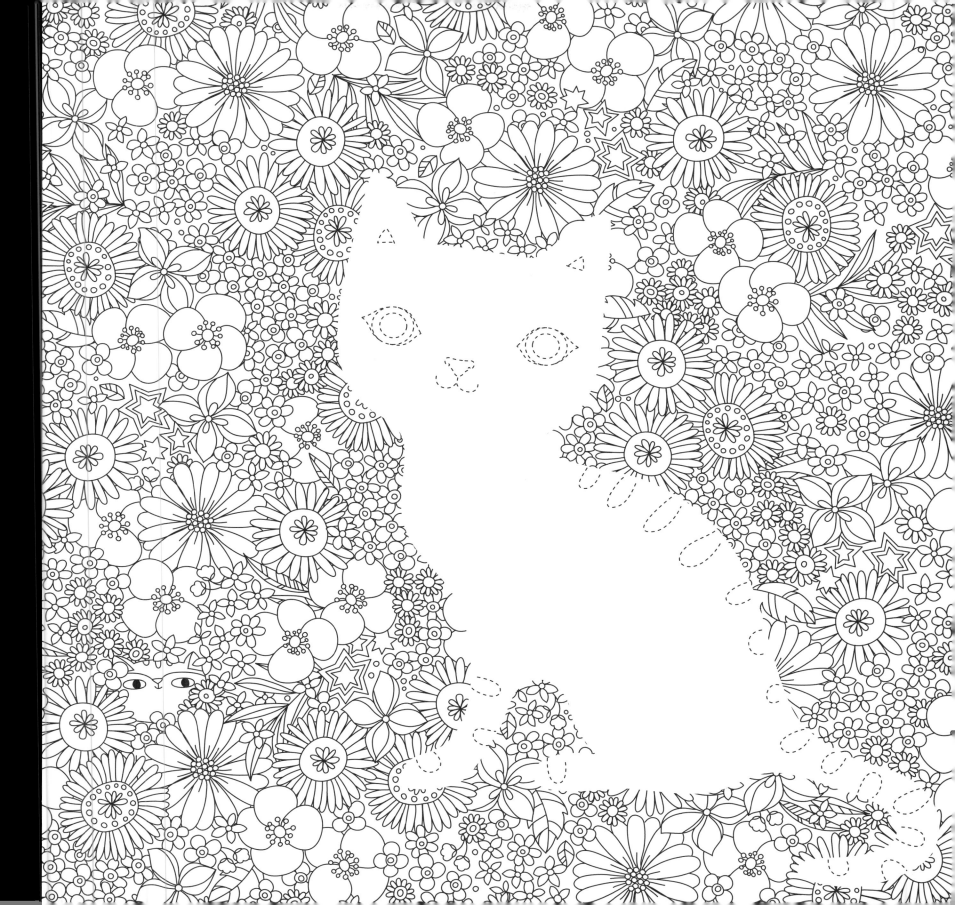

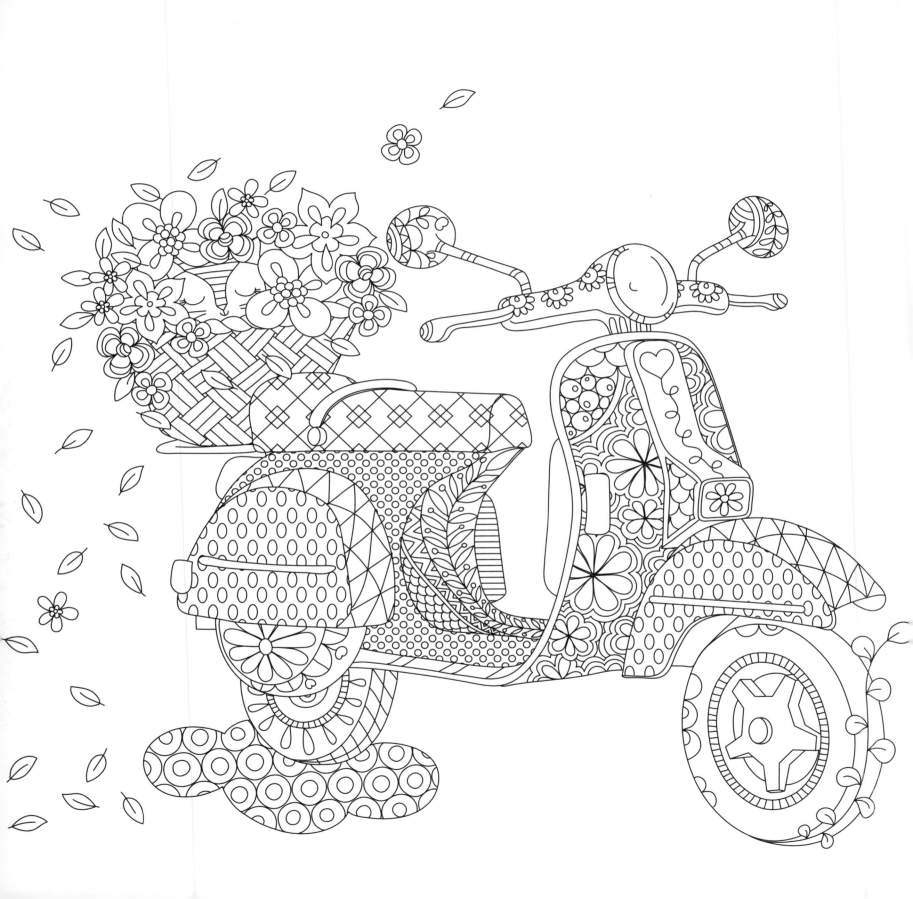

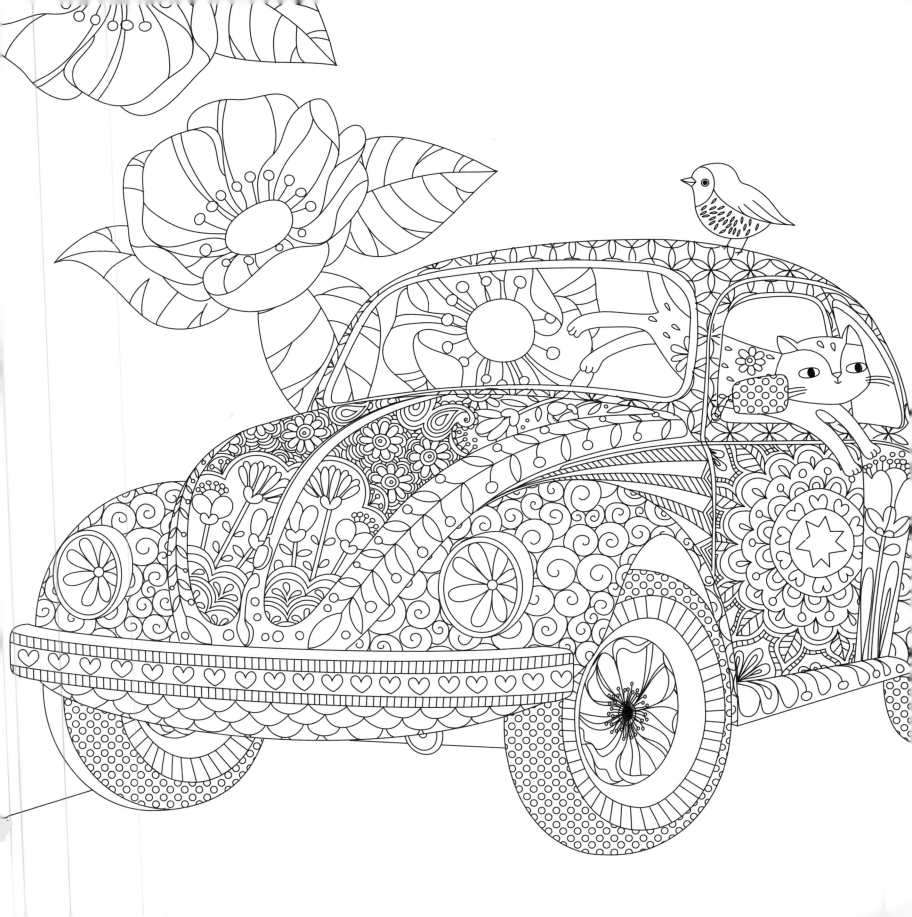

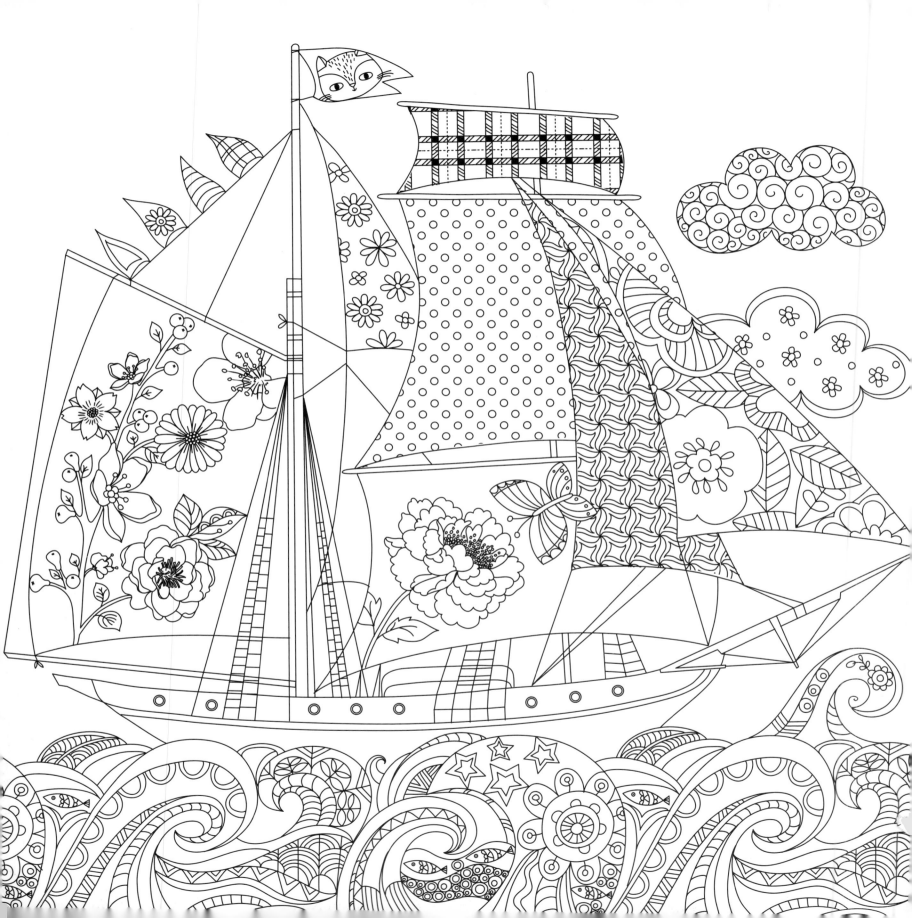

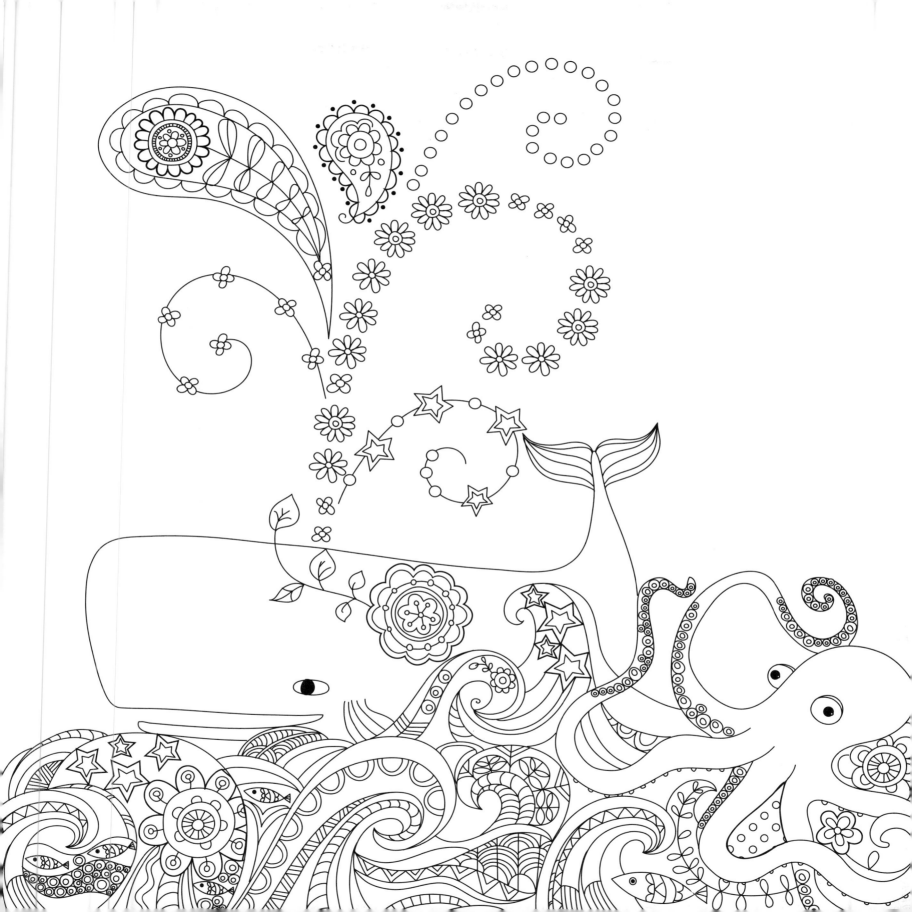

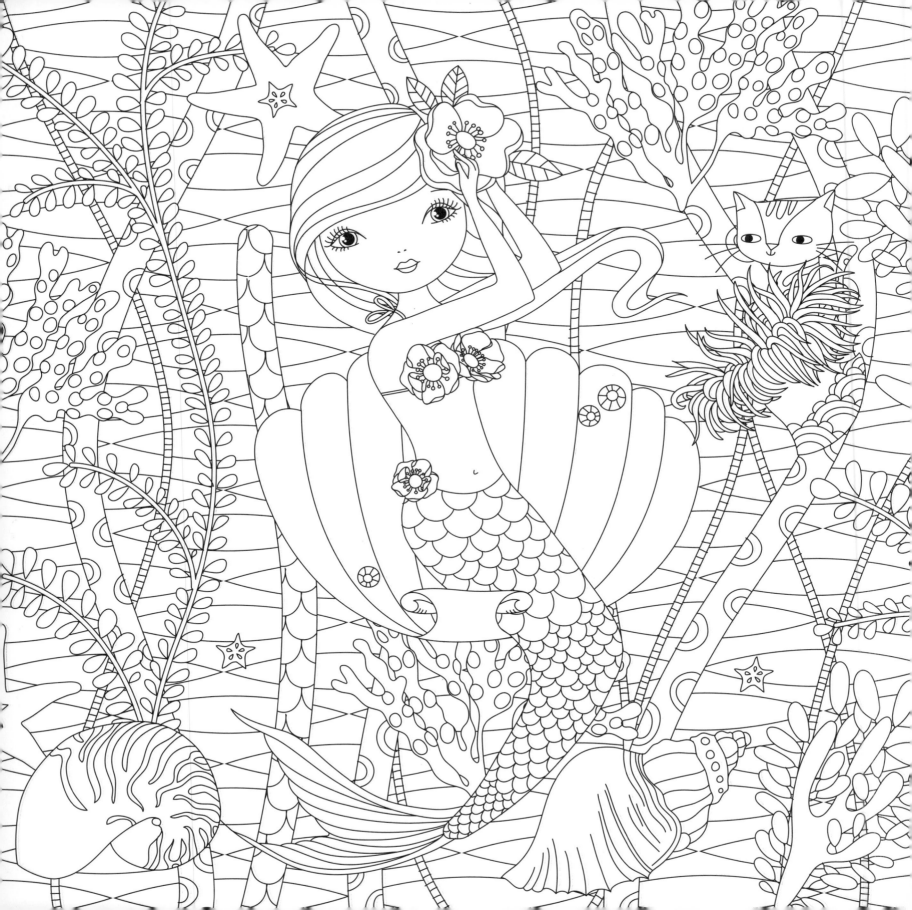

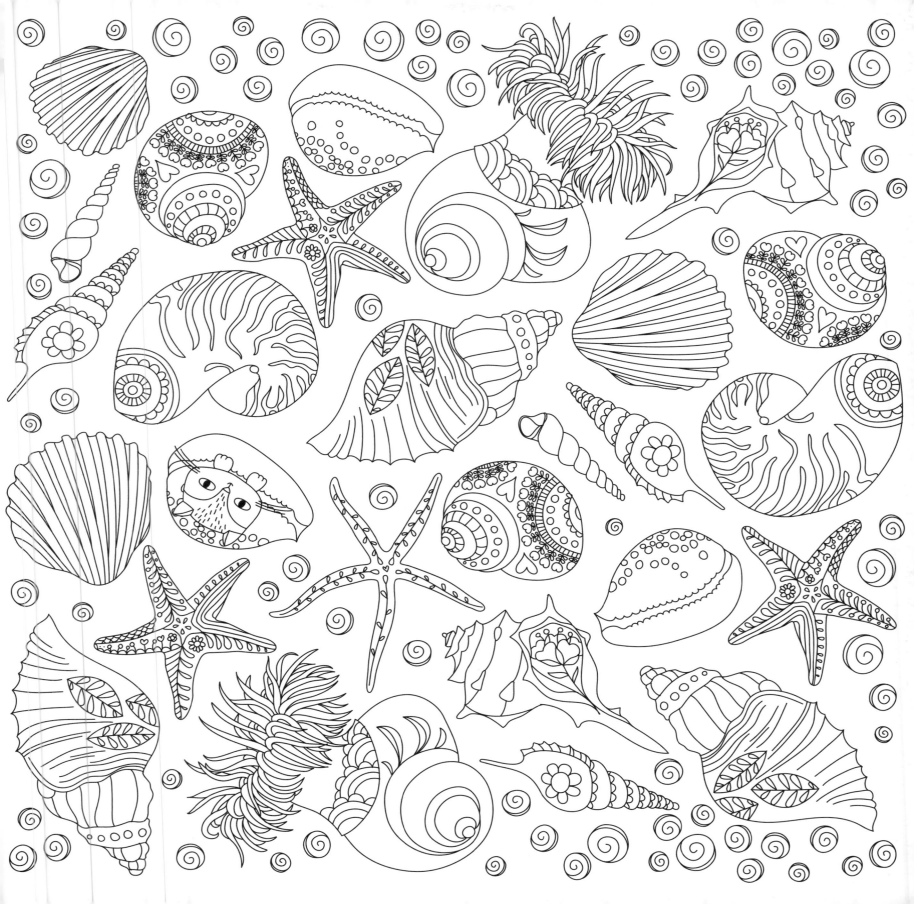

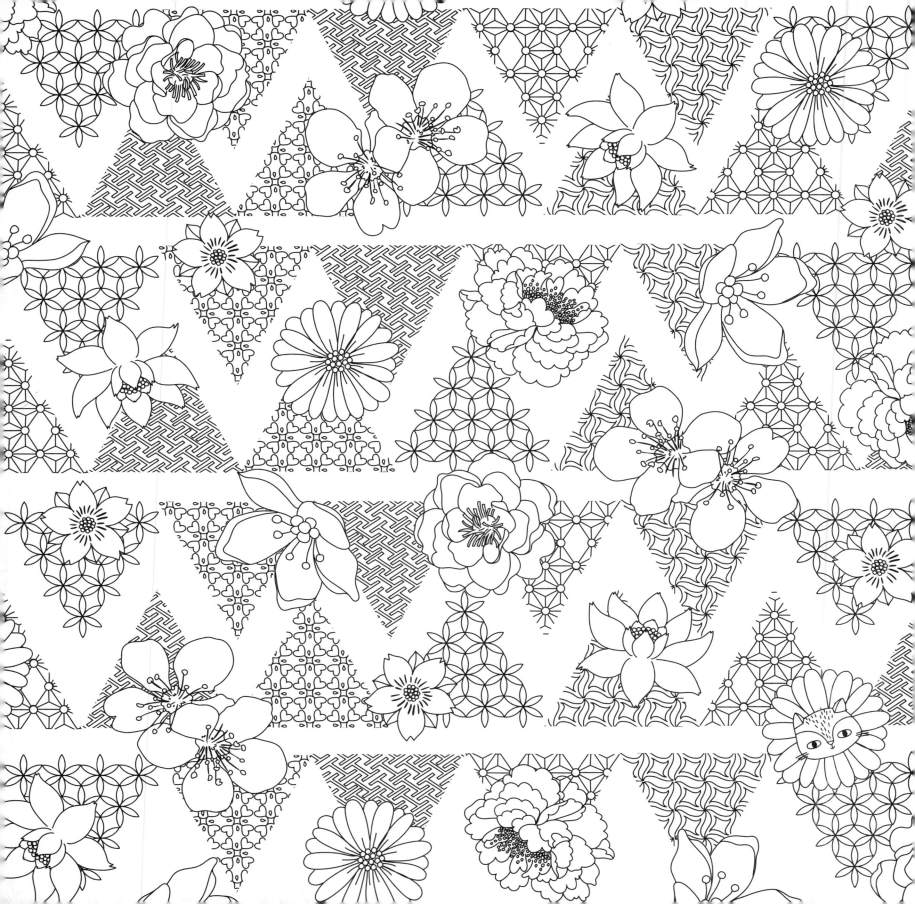

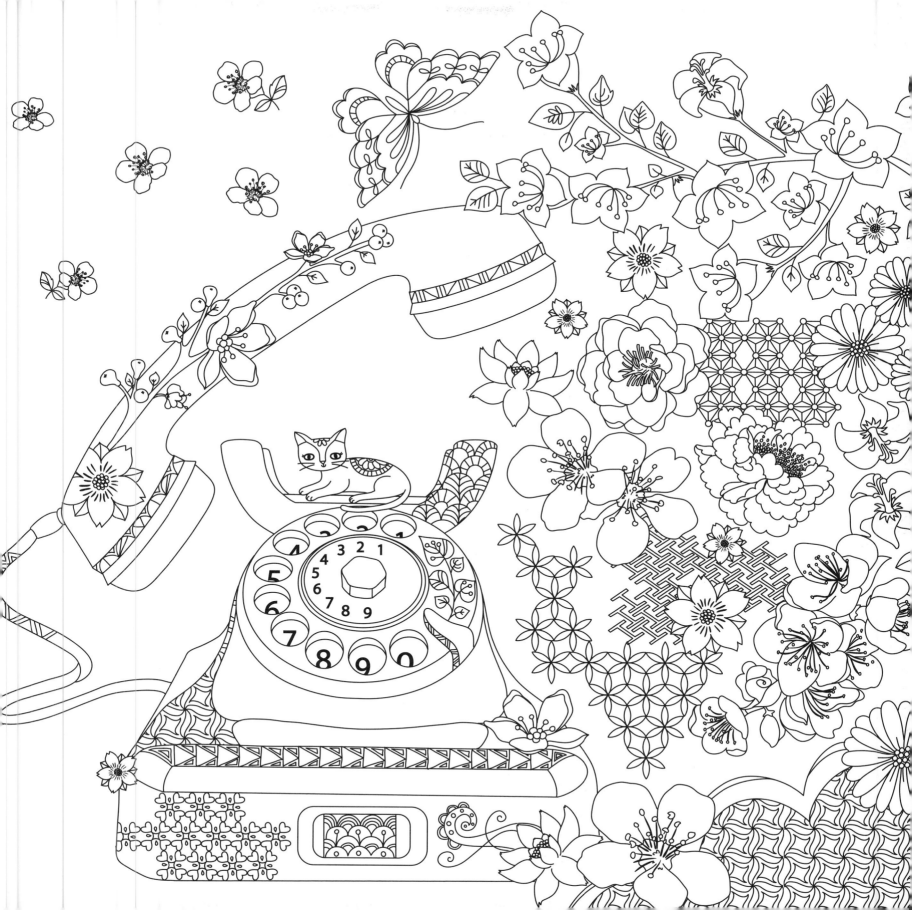

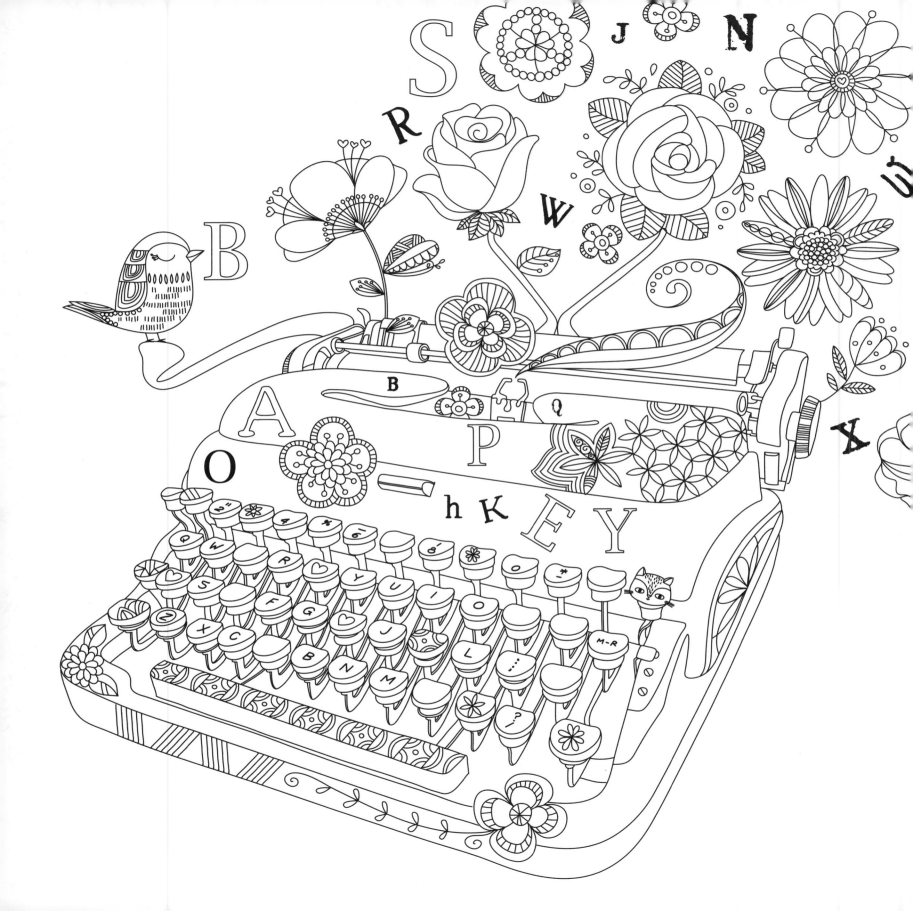

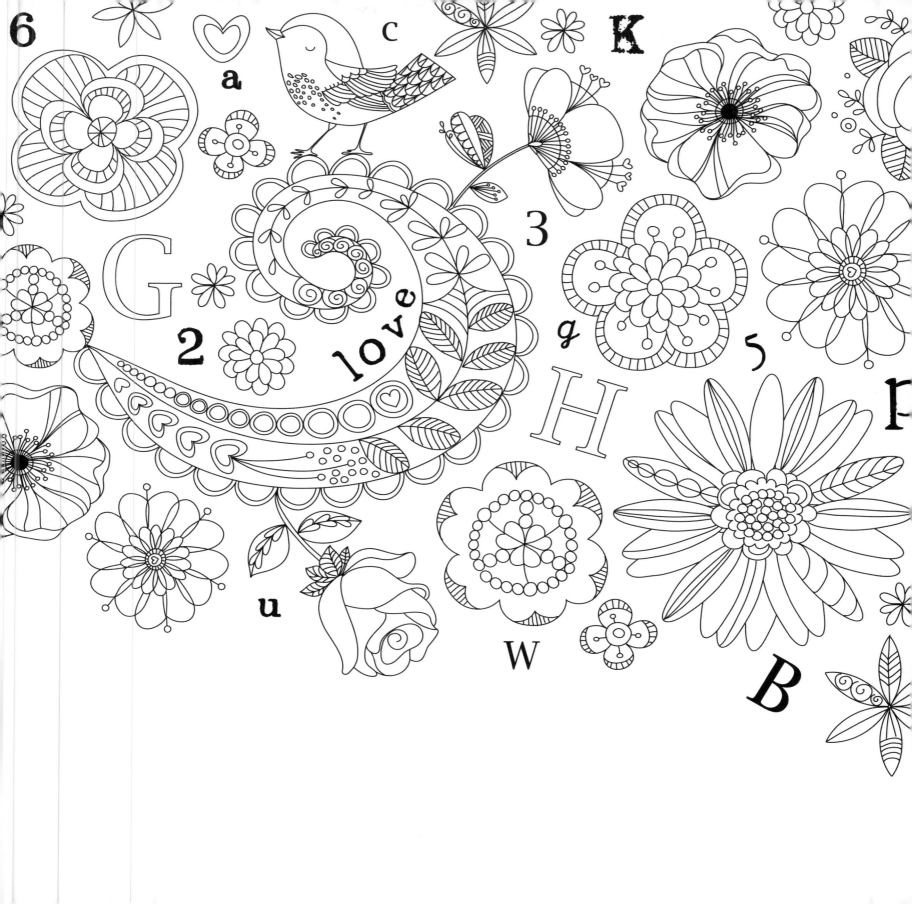

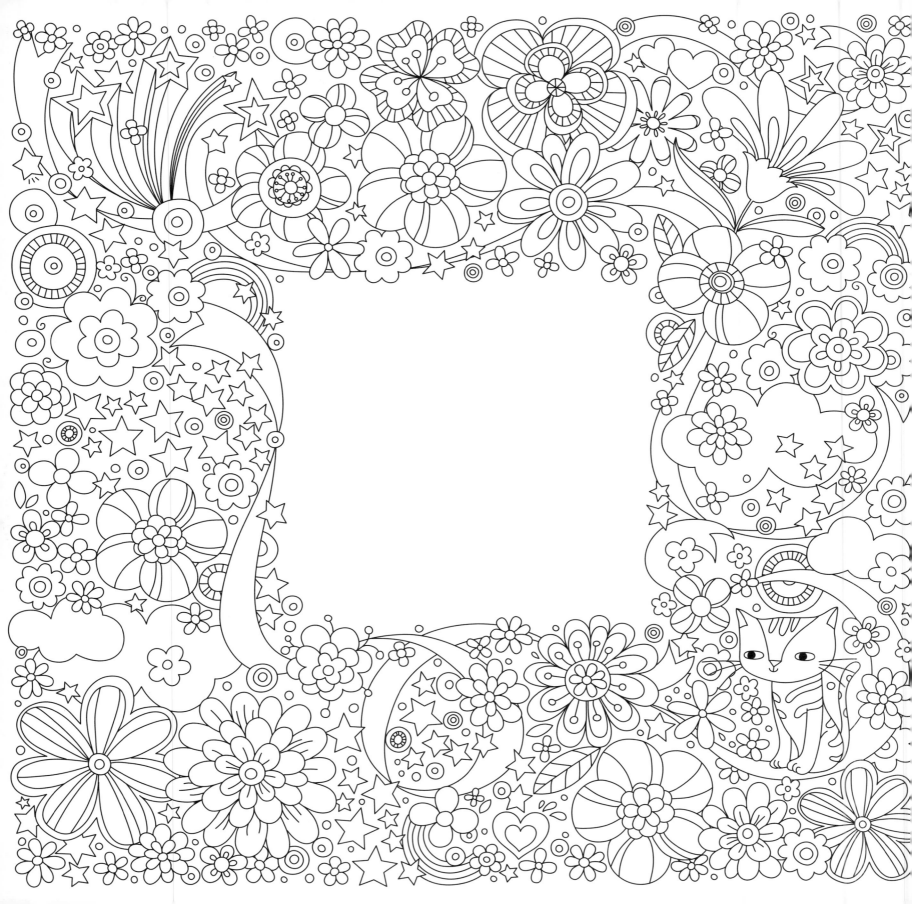

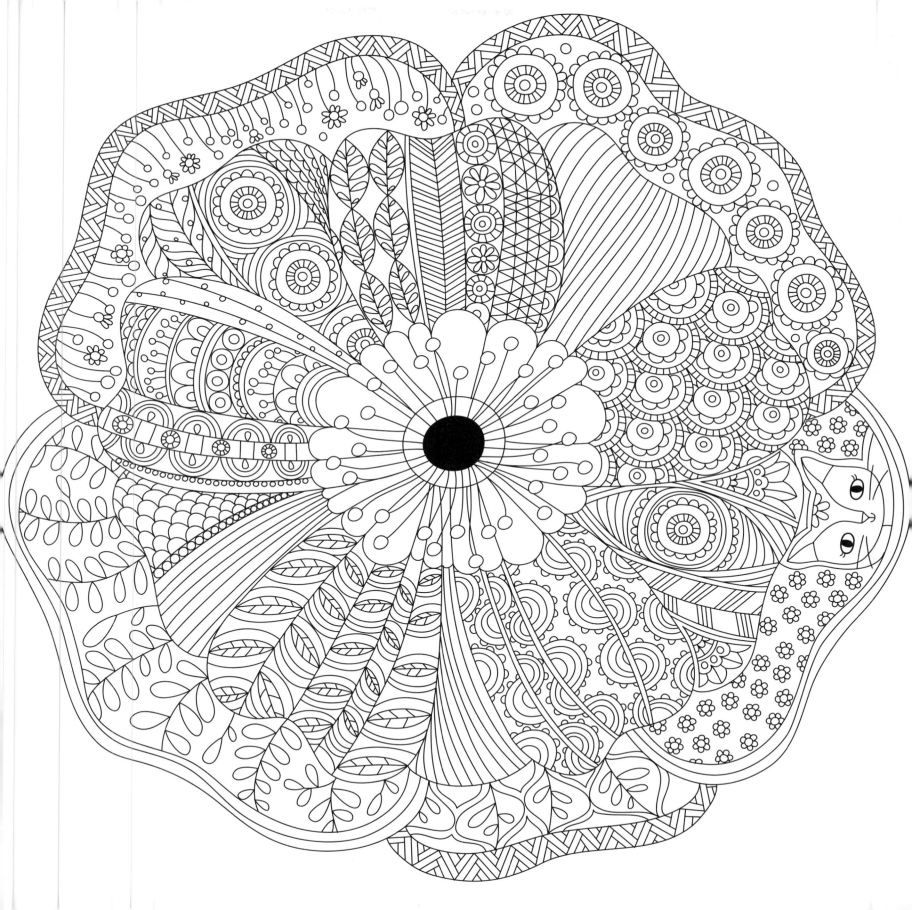

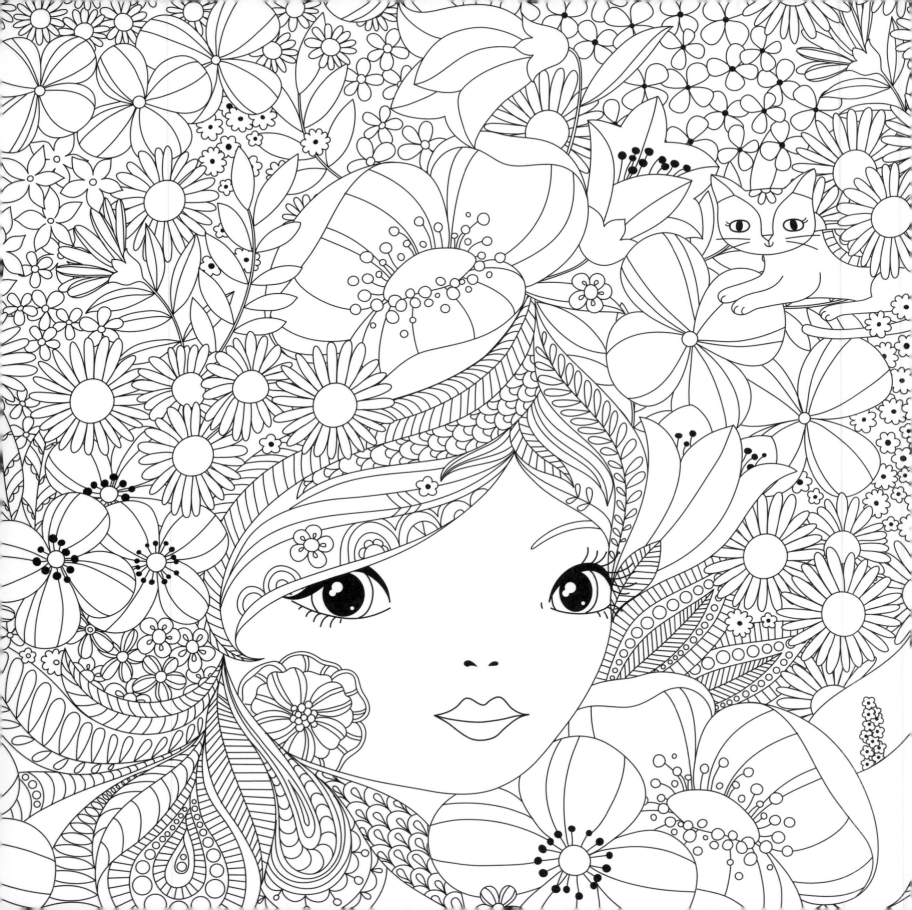

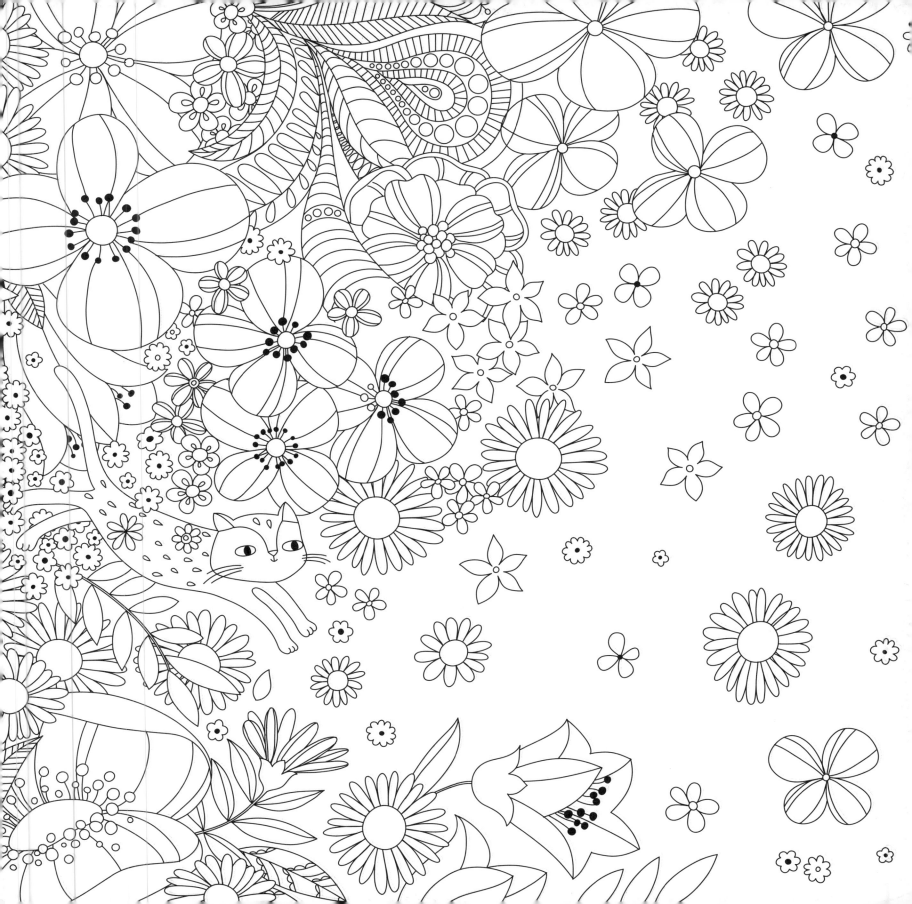

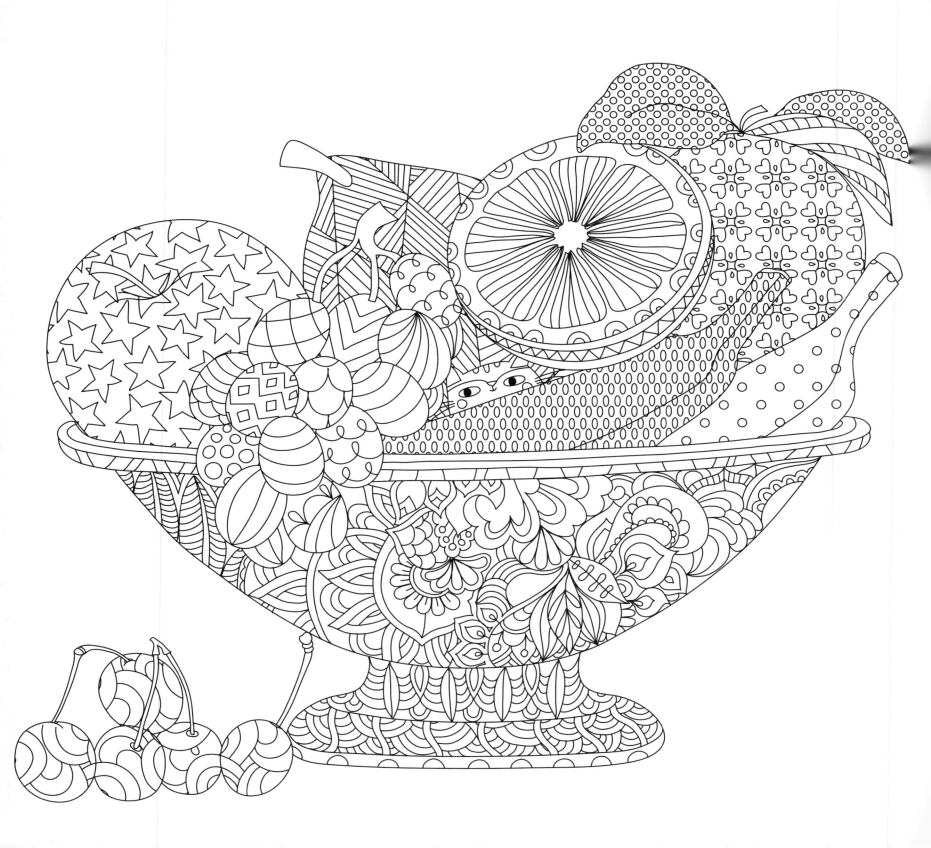

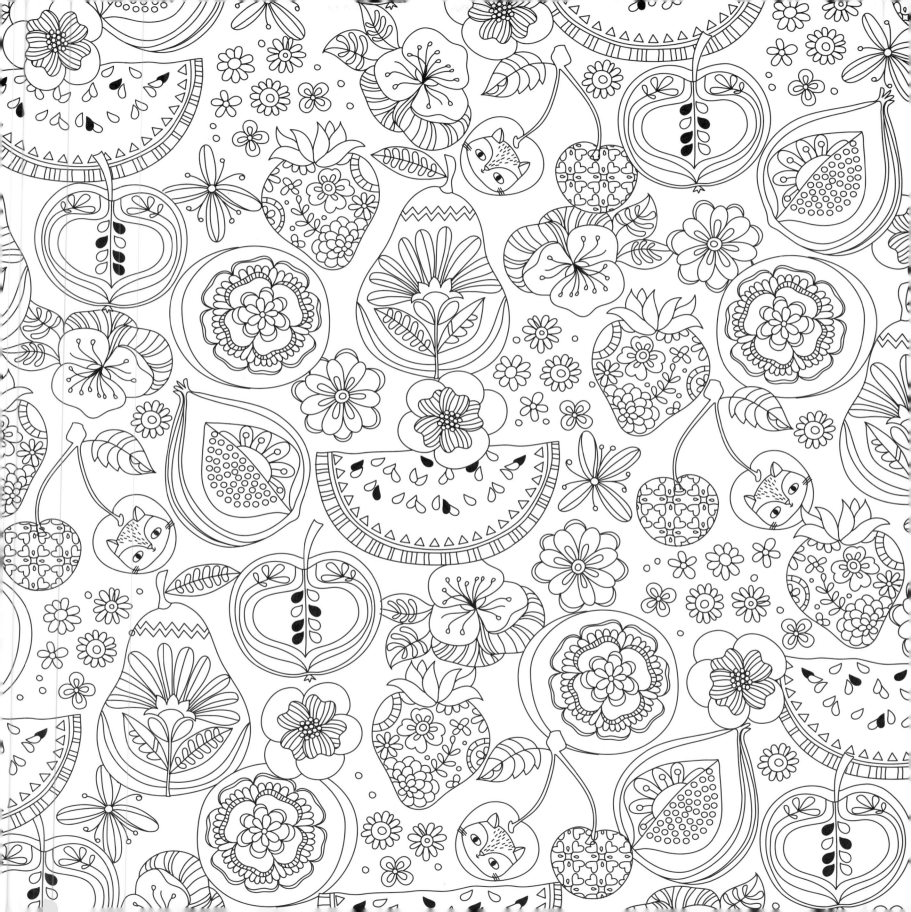

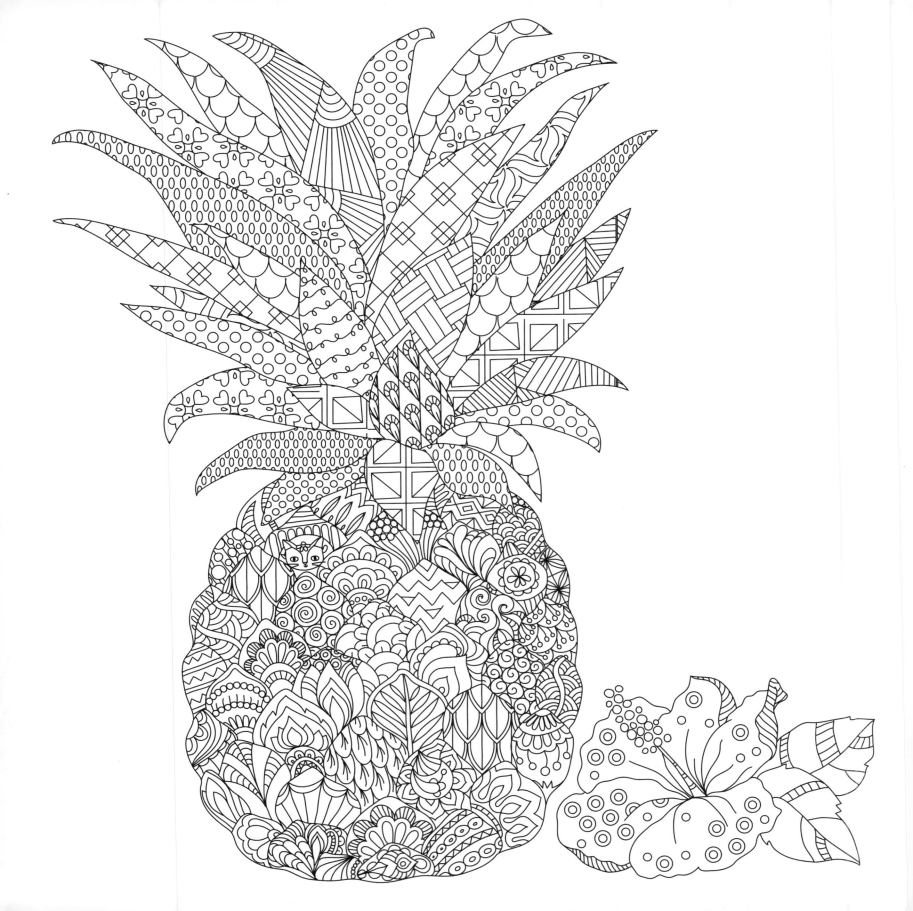

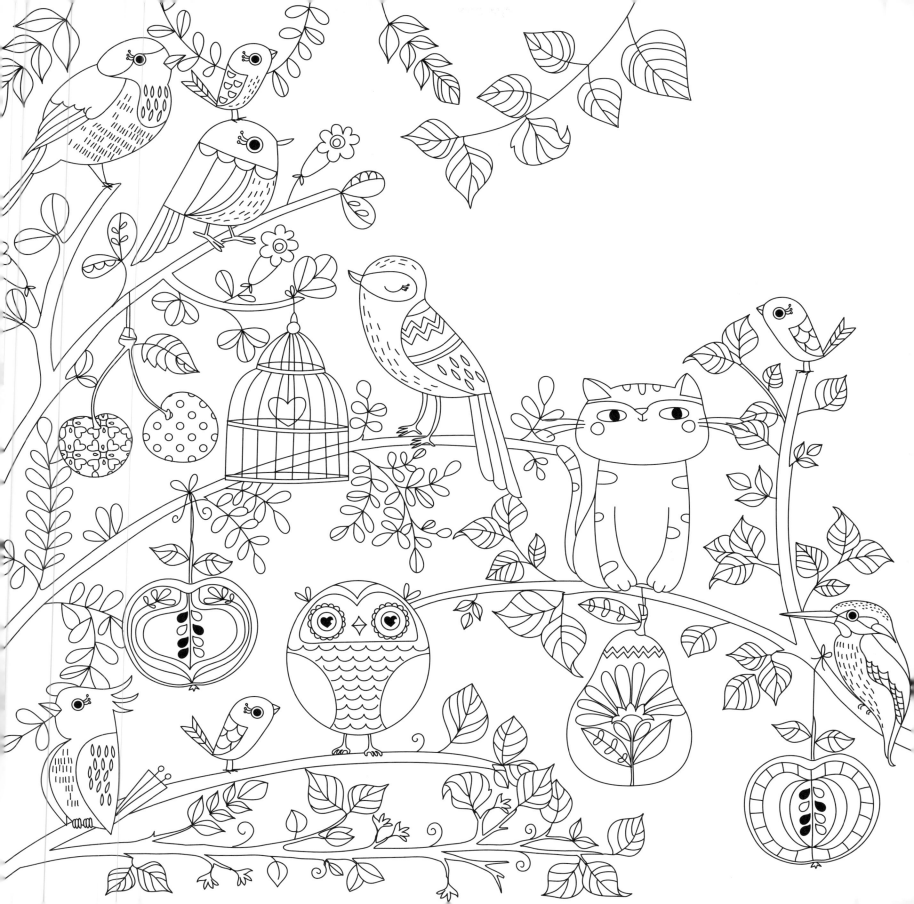

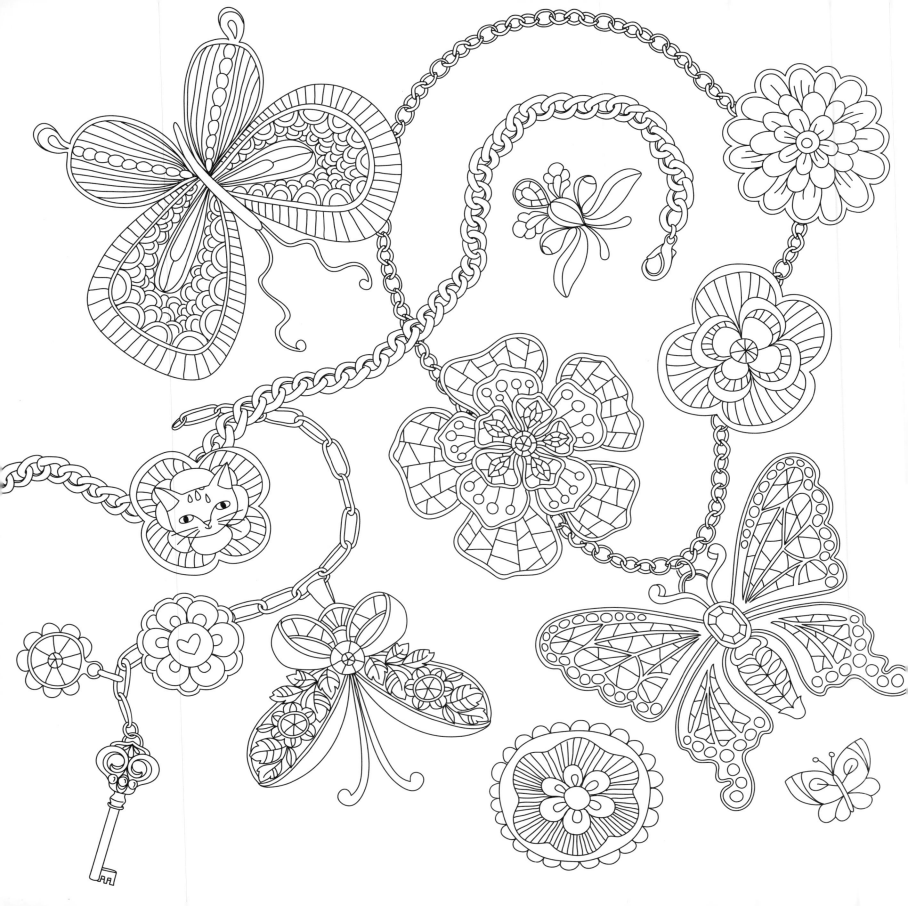

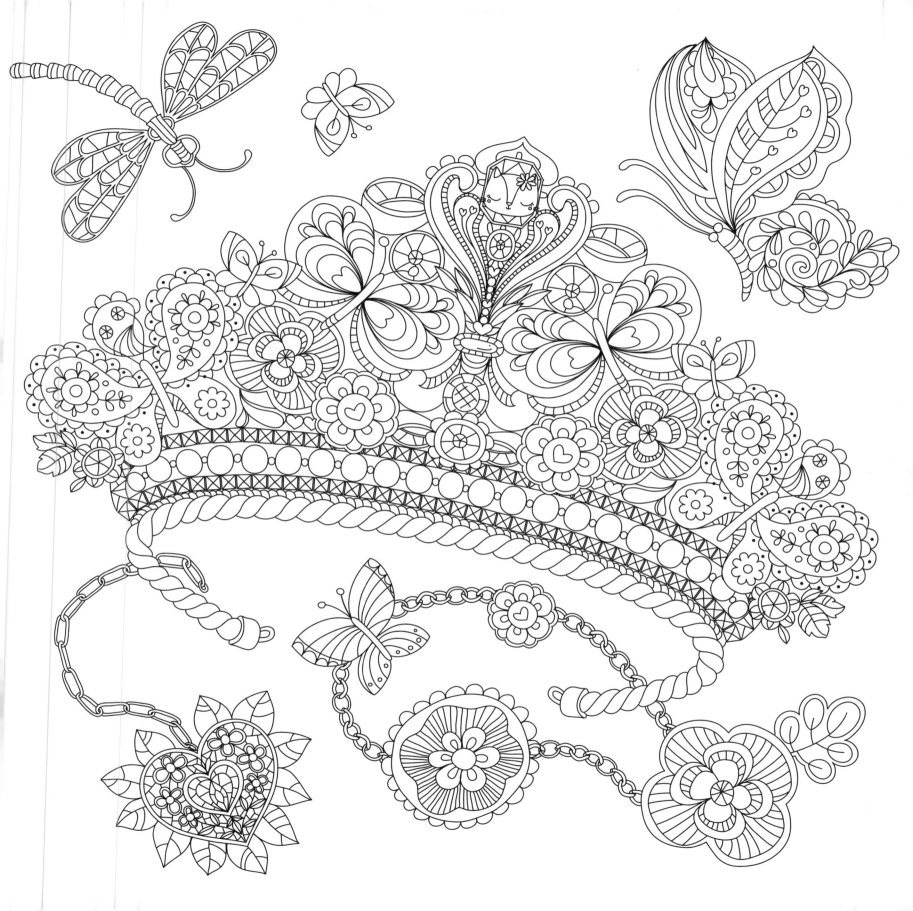

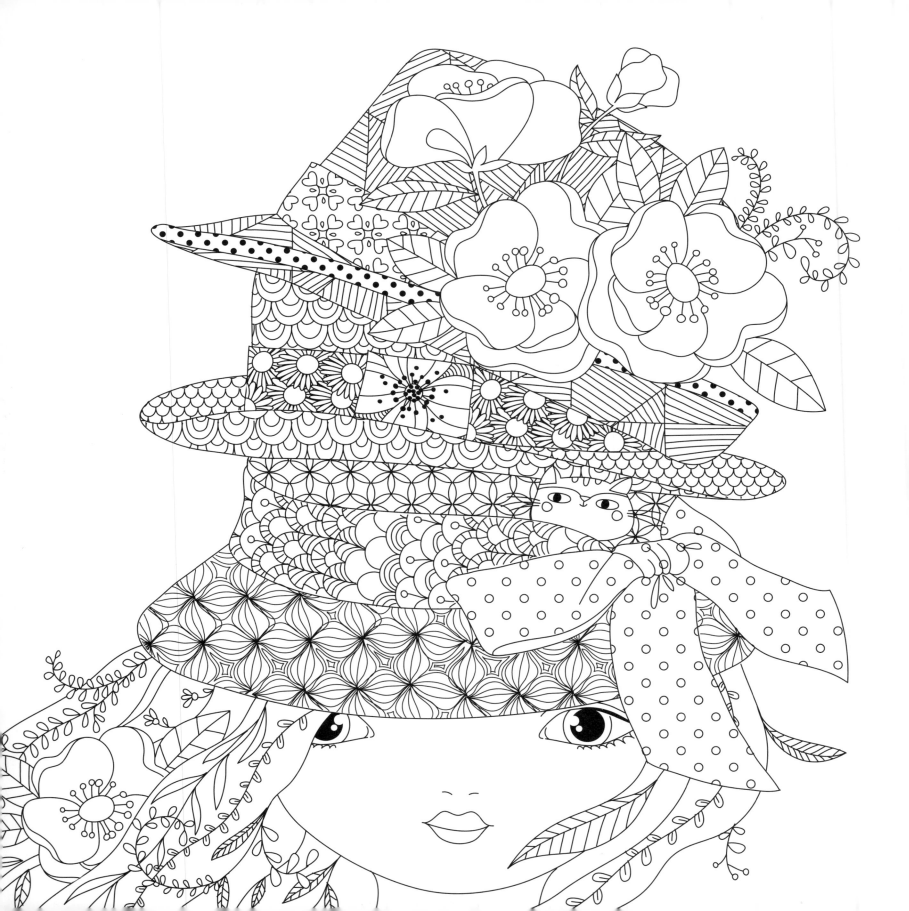

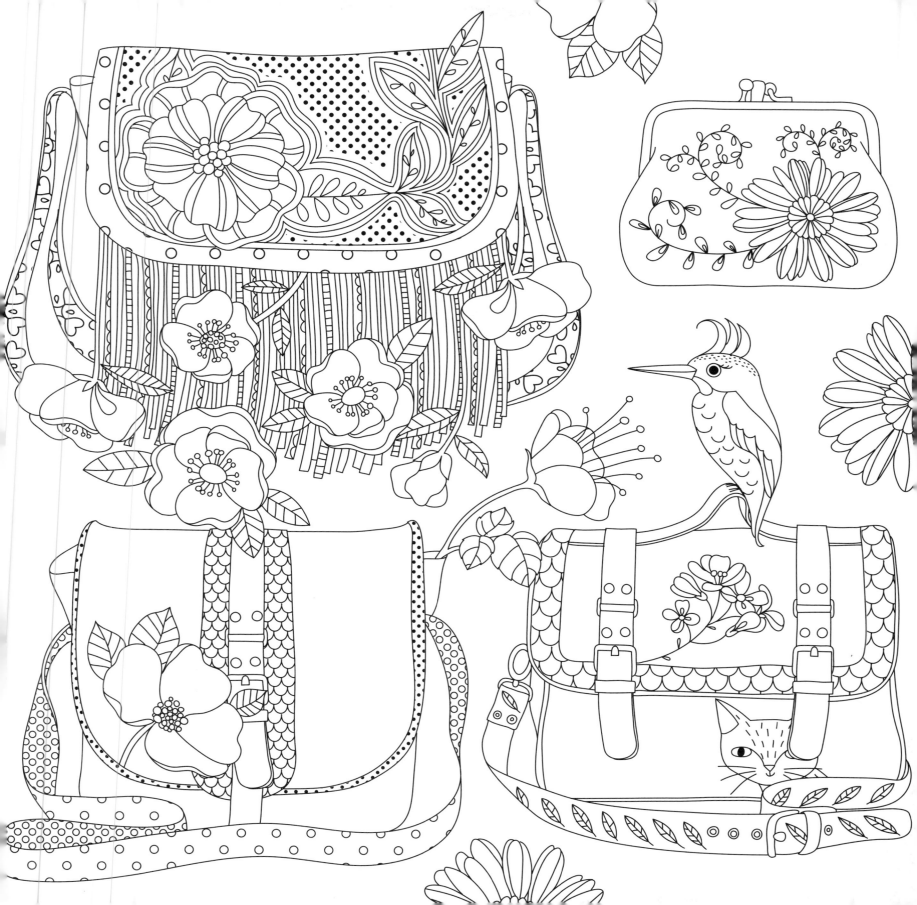

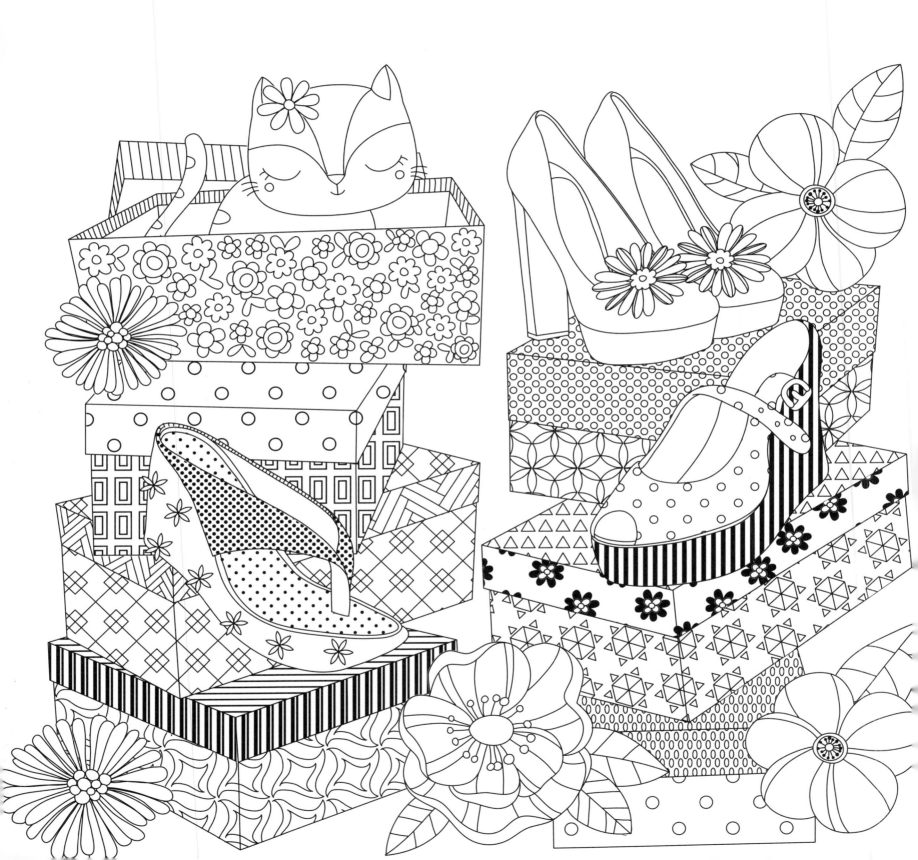

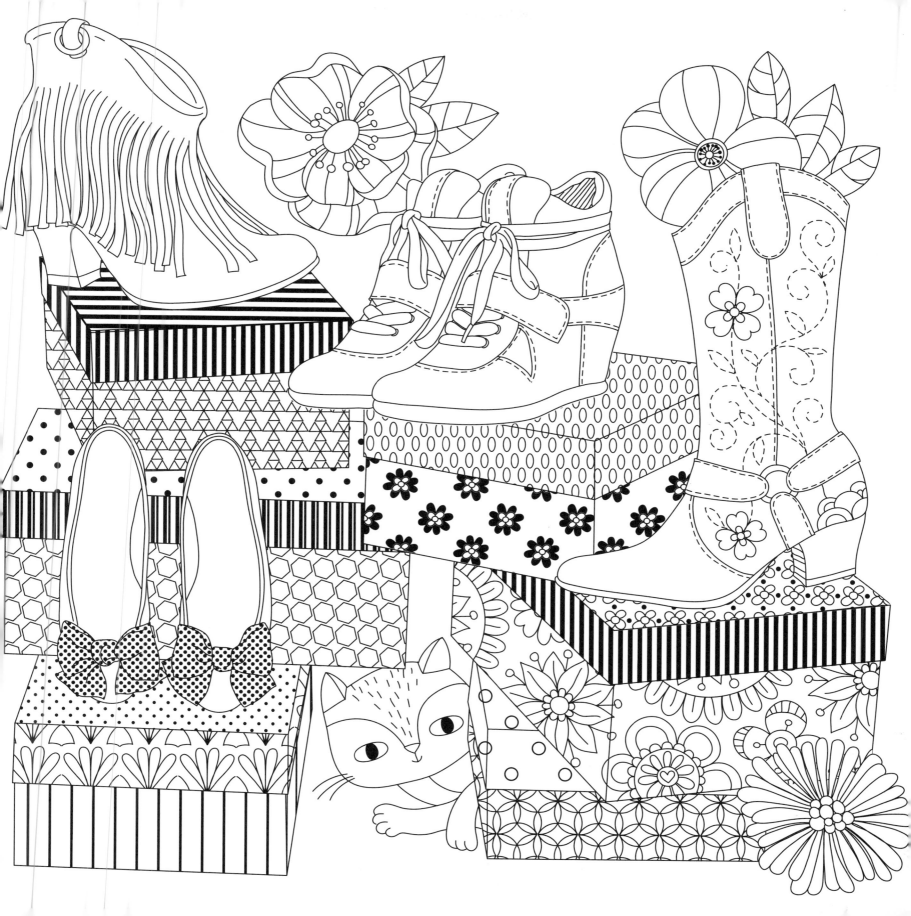

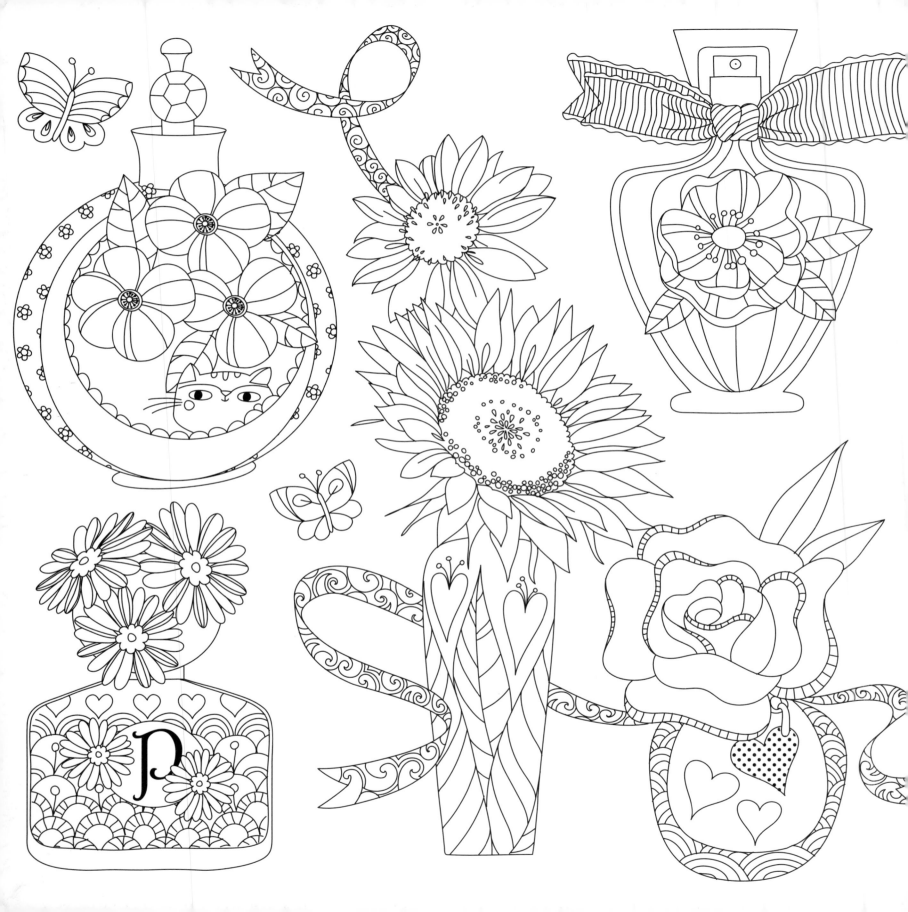

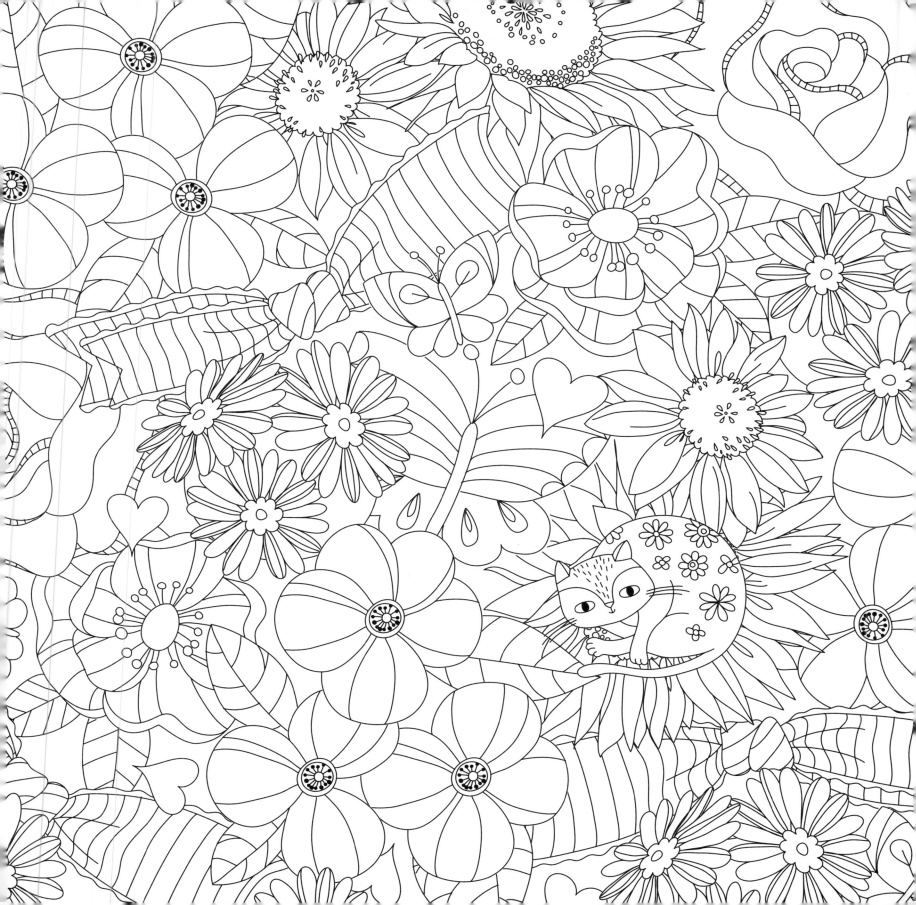

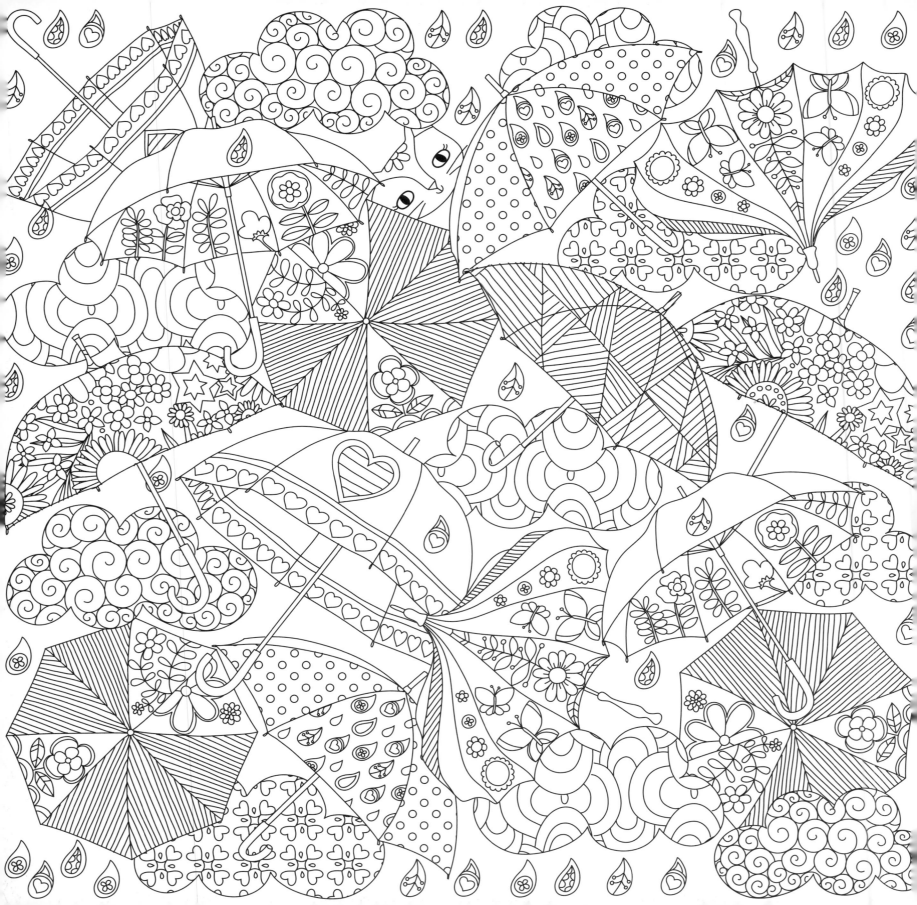

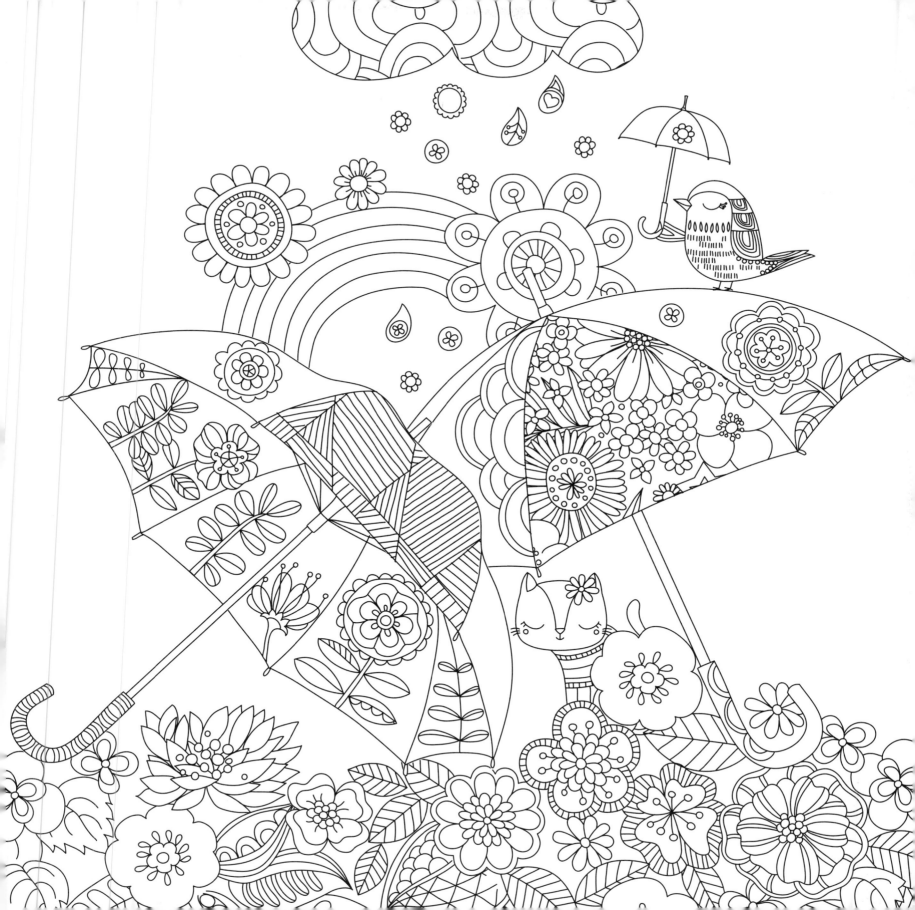

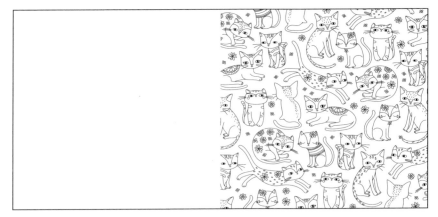

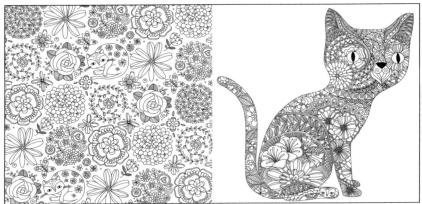

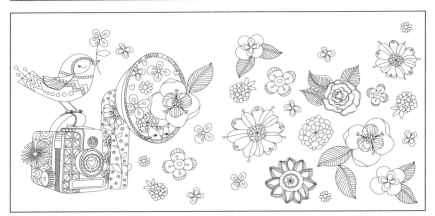

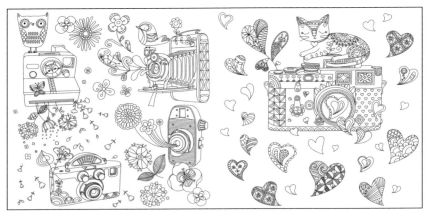

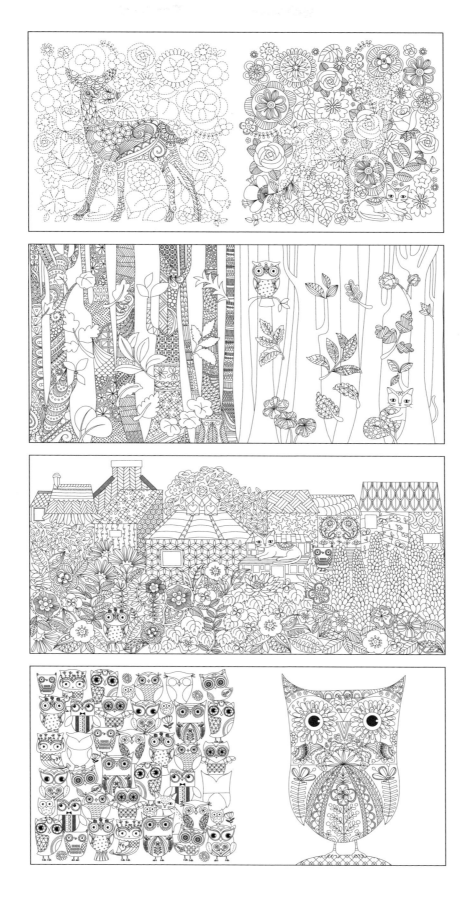

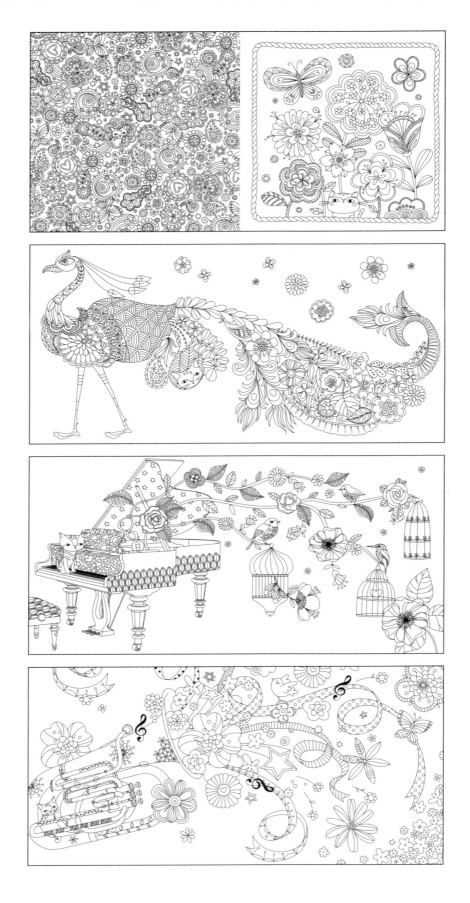

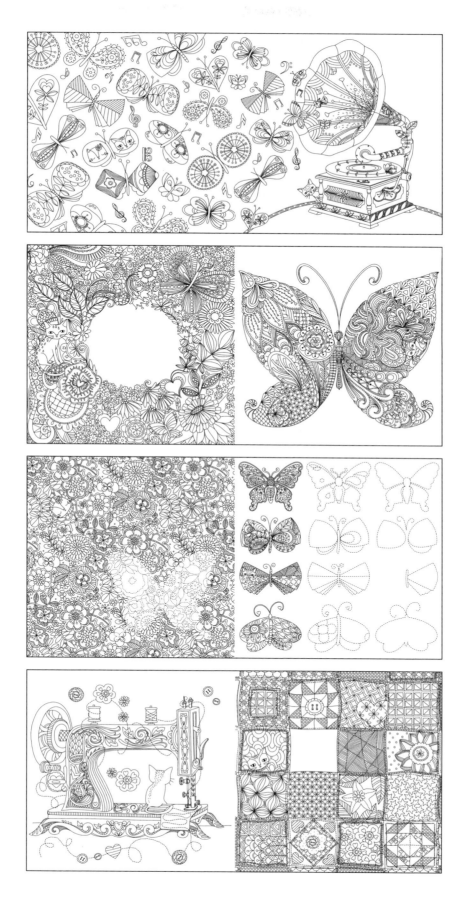

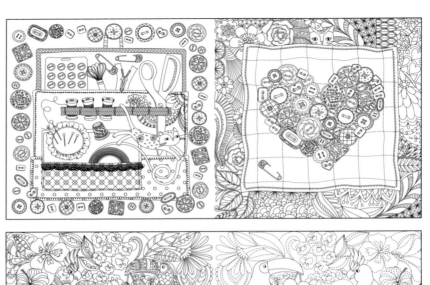

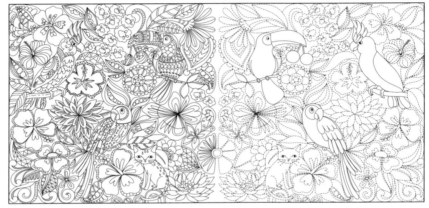

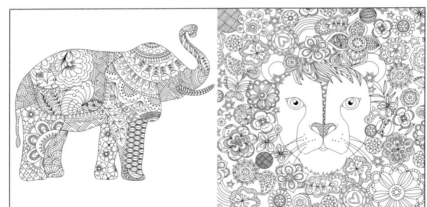

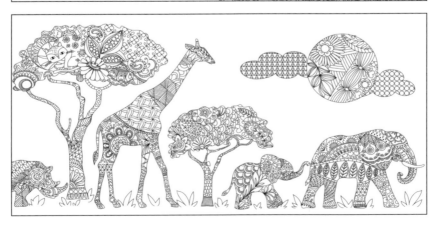

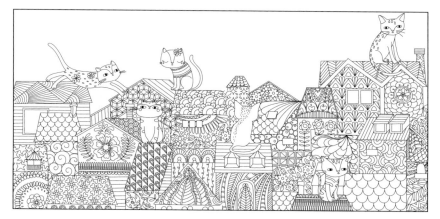

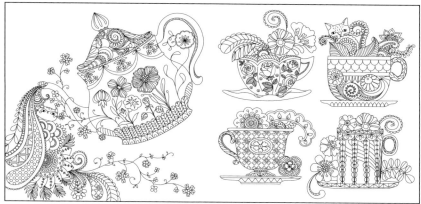

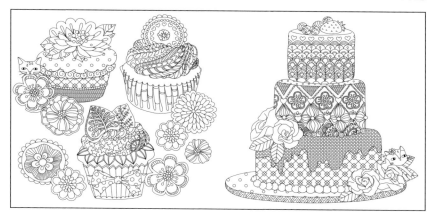

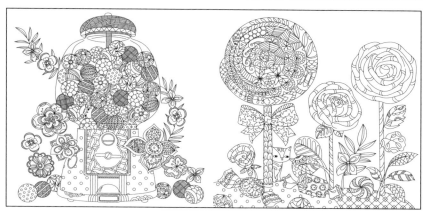

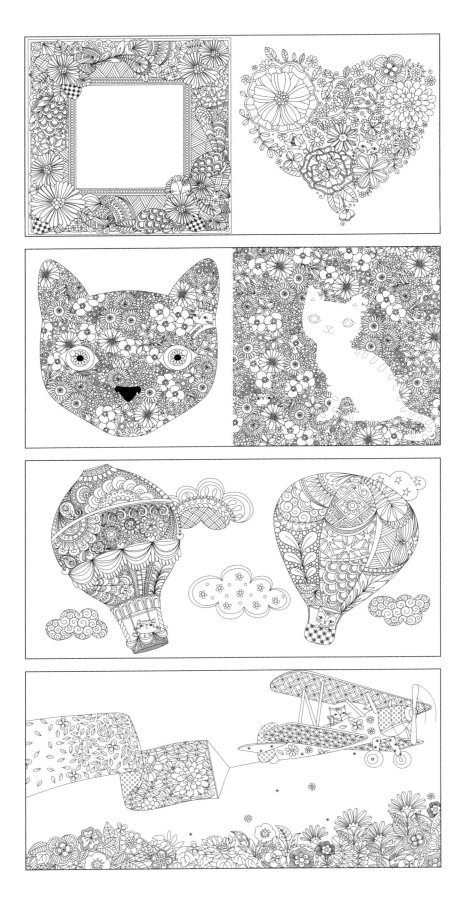

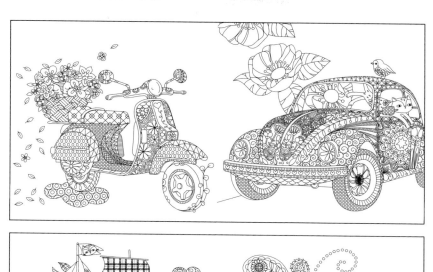

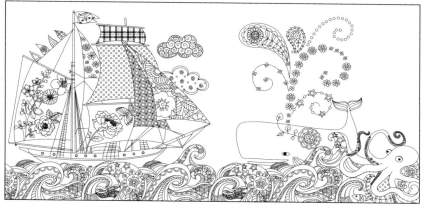

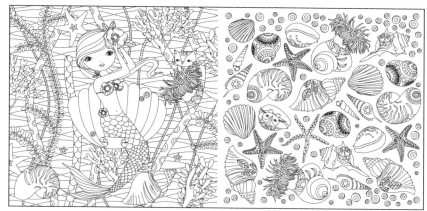

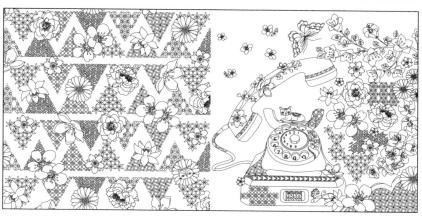

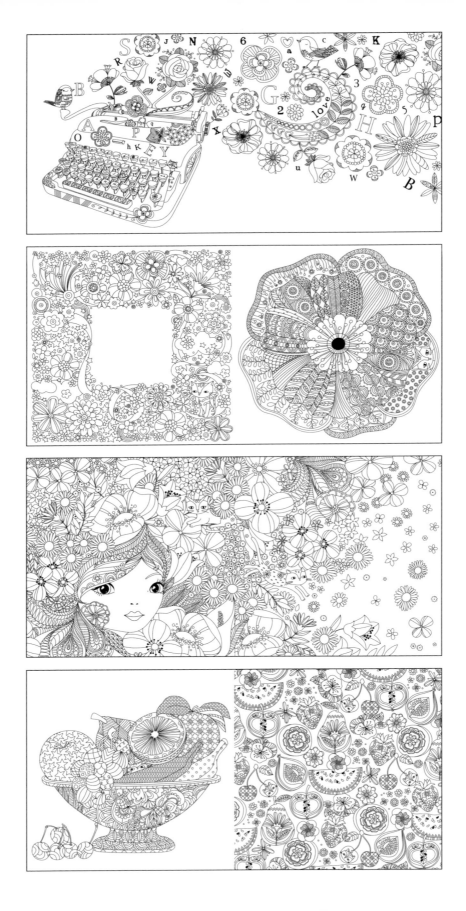

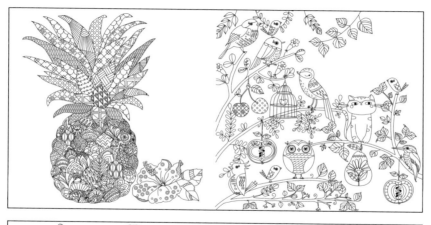

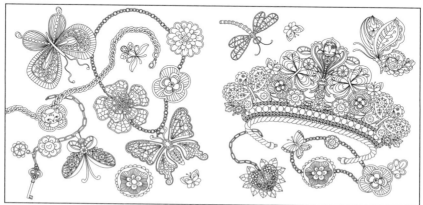

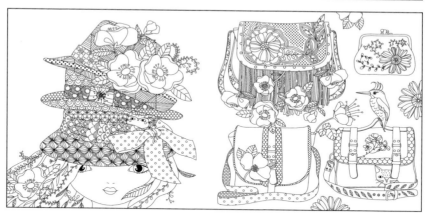

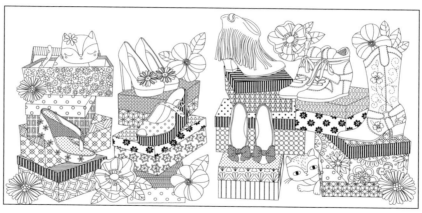

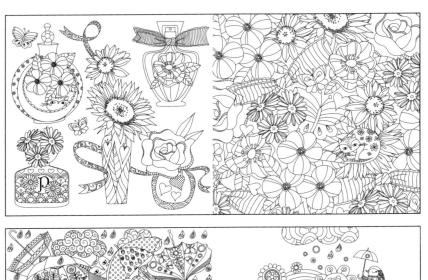

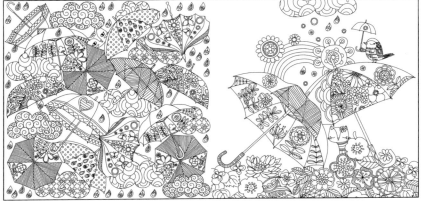